IMAGES
of America

ROSEBURG

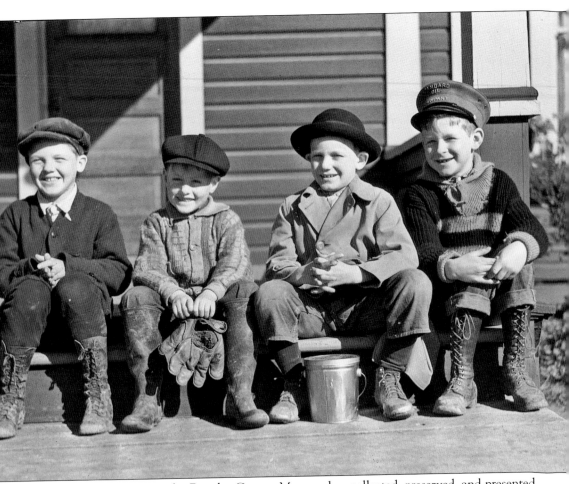

For more than 40 years the Douglas County Museum has collected, preserved, and presented the history of the Umpqua Valley. The museum is unique in that it interprets both the natural and cultural history of the region—visitors discover anything from 100 million-year-old fossils from when Oregon was under the sea to handmade quilts that came with pioneer families on the Oregon Trail. As this book shows, the museum is also rich in historic images available to the public. More than 25,000 photographs ranging from the 1850s through the mid-20th century detail daily life in southern Oregon. Discover more at www.douglasmuseum.com. (Courtesy of the Douglas County Museum.)

On the Cover: These children are ready to do a maypole dance in front of the Douglas County Courthouse. The annual Strawberry Carnivals, held between 1909 and 1925, involved large amounts of food, parades, and floats covered with beautiful flowers and lovely young women. (Courtesy of the Douglas County Museum.)

IMAGES
of America

ROSEBURG

Diane L. Goeres-Gardner and
the Douglas County Museum

ARCADIA
PUBLISHING

Published by Arcadia Publishing
Charleston, South Carolina

Printed in the United States of America

Library of Congress Control Number: 2009936031

For all general information contact Arcadia Publishing at:
Telephone 843-853-2070
Fax 843-853-0044
E-mail sales@arcadiapublishing.com
For customer service and orders:
Toll-Free 1-888-313-2665

Visit us on the Internet at www.arcadiapublishing.com

*This book is dedicated to my wonderful husband,
Mike. You make everything worthwhile.*

Diane L. Goeres-Gardner is an award-winning author of two previous history books: *Necktie Parties: Legal Executions in Oregon, 1851 to 1905* published in 2005, and *Murder, Morality and Madness: Women Criminals in Early Oregon* published in 2009, both by Caxton Press.

CONTENTS

ACKNOWLEDGMENTS

Unless otherwise noted, the images in this book were provided by the Douglas County Museum of History and Natural History in Roseburg, Oregon. All others who submitted images are identified. Thank you to everyone who provided pictures or information. Below is a list of those who helped by scanning pictures, tracking down research, or providing information: Debra Barner of the Umpqua Forest Service, Roseburg fire chief Jack Cooley, Aaron Dunbar of the Roseburg City Police, the Ford Foundation, Thomas and Randy Garrison, Don Good, Wally Hunnicutt, Summer James, Charlotte Neal Long, museum volunteer Richard McQuillan, Tamara Osborne of Umpqua Dairy, Douglas County Library volunteer Janet Ring, president of the Douglas County Historical Society John Robertson, Mike Rondo of the Cow Creek Band of Umpqua Indians, Father Selwyn of the St. Joseph's Catholic Church, and Ray Sims.

INTRODUCTION

The Umpqua Valley sits surrounded by the Cascade and Coastal Mountains about 175 miles south of the Columbia River. From high overhead it appears as a semi-circular turtle shell with the Umpqua River as its tail, draining into the Pacific Ocean at Reedsport. The North Umpqua River tumbles cold, blue, and furious from the Cascade Mountains. The South Umpqua River originates near Crater Lake and is more sedate and shallow, curling through the many green meadows and valleys. They meet in mighty triumph at what is now called River Forks Park to form the main Umpqua, continuing to flow 96 miles to the ocean.

The mountain barrier keeps the weather mild in the winter and summer—a perfect valley for fishing, agriculture, timber, and livestock. Native Americans recognized the wonderful resources available and settled here many thousands of years ago. The Klickitats and the Cow Creeks joined the Umpqua Tribe and traded with tribes in the Willamette Valley to the north and the Rogue River to the south. The story goes that they called the river *un-ca*. Some translations say the word means river, and others say it means full stomach or satisfied.

In 1828, Jededia Smith traveled north from Sacramento with a group of fur traders heading for the Hudson's Bay Company in Vancouver. Most of the men were killed as they tried to cross the Umpqua River near the coast. Smith and three others survived. Following their escape and their report naming the abundance of fur bearing animals, the trapping industry recognized the potential of southern Oregon, and a few years later the Hudson Bay Company opened Fort Umpqua on the main Umpqua River.

Fort Umpqua was built a mile upstream from Elkton in 1836 and served as a trading post for Native Americans and white settlers coming into the valley. Before burning down in 1851, it initiated agricultural development by importing various fruit trees, seeds, and cattle. Delaware and other Algonquin Indians worked for the company. It is also possible that the Algonquin word *nom-quau* (or *nobp-quau*), which means canoe, may have been the origin of the word *Umpqua*.

In 1847, settlers from the Willamette Valley traveled by packhorse south from Vancouver to Klamath Falls. Jesse, Lindsay, and Charles Applegate were part of that pack train, and they fell in love with the country, returning with their families to build homes in the Yoncalla area. On January 6, 1852, the Oregon territorial legislature created Douglas County and appointed the small town of Winchester as the county seat.

About 4 miles south, a settler named Aaron Rose had a better idea. Rose had arrived with his family in August 1851 while traveling north over the Applegate-Scott trail. He purchased land from Louis Raimey and filed for a Donation Land Claim of 640 acres. The land was situated on the east bank of the South Umpqua River on a wide alluvial plain. He had it surveyed and platted as a town, which he named Deer Creek. The Deer Creek post office was opened on September 28, 1851. On July 16, 1857, the name of the town was changed to Roseburgh. On March 7, 1894, the "h" was dropped.

Wanting his infant town to grow, Rose portioned out land for schools, churches, and public buildings. By March 1854, when an election was held to officially designate the county seat, Deer Creek was ready. The day of the election, Rose invited the settlers from Lookingglass and areas south to visit his tavern and accept his hospitality. Together the settlers, voting as a block, elected Deer Creek the county seat. A few years later, buildings from the town of Winchester, including the U.S. Land Office, were physically moved 4 miles south to Roseburg.

Gradually the town grew, as Thomas Owens built a ferry to convey passengers back and forth across the river in 1854. A sawmill was constructed to provide timber for new buildings. Lewis Bradbury built a store in 1853 to join Rose's tavern. The first physician, Dr. Salathiel Hamilton, arrived in 1855 with his wife Sarah and set up a pharmacy and physician's office. A weekly newspaper, *The Roseburg Express*, was first published on November 7, 1859, by L. E. V. Coon and Company. It cost $3 a year to subscribe. During the Indian Wars of 1855, Roseburg served as the headquarters for the Northern Battalion of the Oregon Volunteers. Providing supplies for the army gave a boost to the small town's economy and helped attract new residents.

Aaron Rose farmed his donation land claim for 18 years, and ran a butcher shop, a tavern, and a general store. In 1855 he was elected a member of the territorial legislature. He donated three acres of land and $1,000 for a county courthouse. In 1904, Rose High School was built at a cost of $17,000 on land Rose donated. He facilitated the Oregon and California Railroad by donating a right-of-way and station grounds in 1872, and helped finance the Coos Bay Military Wagon Road in 1873. The railroad created a round house in the center of town where freight and passengers could be transferred to wagons or stages to continue south to California. The Coos Bay wagon forged west over the mountains and opened Roseburg to traffic from the coast. The historic Mill-Pine neighborhood was created out of Rose's donation land claim.

Soon came a jail, schools, churches, and a hospital. In 1894, the Oregon State Soldier's Home was built to house retired and homeless veterans. Pres. Herbert Hoover chose Roseburg to build a West Coast National Veteran's Home and Hospital in 1931, creating jobs and an influx of money the town needed to survive the Great Depression.

In the early hours of August 7, 1959, a terrible explosion and fire decimated the center of downtown Roseburg. The Blast left 300 businesses damaged in a 30-block radius and leveled nearly all the buildings in an eight-block area closest to the center of the explosion. Investigation revealed a freight truck carrying two tons of dynamite and four-and-one-half tons of ammonium nitrate had been parked near the Gerretsen Building Supply Company building. Where the truck once stood, a crater 52 feet across and 12 feet deep remained. The Blast killed 14 people and injured 125. It caused $12 million in damage and forever changed the face of downtown Roseburg.

Today Interstate 5 curves around the base of Mount Nebo and bisects the town, bringing thousands of tourists and travelers to enjoy Roseburg's seasonal activities and the many natural wonders located nearby.

One

SETTLEMENT

BUILDING A CITY

Whether a town grows to become a city usually depends on luck or location—Roseburg had both. In the beginning, access to the river and the Applegate Trail made transportation an easier process in Roseburg than many other locations. By 1872, when the city was incorporated, there were five churches, twelve saloons, three hotels, seven fraternal lodges, two gristmills, stables, harness shops, dry goods stores, and a brewery. The establishment of the railroad terminus between 1872 and 1882 gave the town a firm foundation to draw bankers, businessmen, and entrepreneurs at a time when Oregon was experiencing a rapid influx of immigrants. The Oregon State Soldier's Home, built in 1894, established a precedent and helped secure the National Veterans Administration Hospital in 1933. The hospital ensured the town's survival during the Depression, and it still draws retired veterans to come live in the nearby green hills and valleys.

Today Roseburg has a population of approximately 21,500, with residents from all over the world. Restaurants offer international cuisine from China, Mexico, Italy, Greece, and Japan. An award-winning daily newspaper, *The News Review*, provides local, national, and international news. Mercy Medical Center has grown from a small country hospital to a regional facility extending care to all of Douglas County. The city remains the governing seat for Douglas County, with a full complement of government offices.

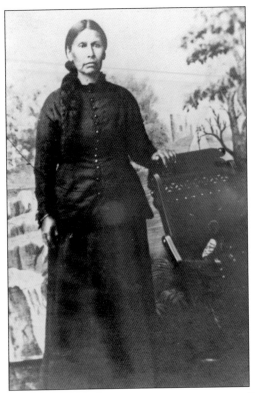

The Cow Creek Indian Tribe were among the first inhabitants of the Umpqua Valley. Susan Nonta Thomason, born in 1859, was a physician and midwife to Native Americans and whites. Her husband, William P. Thomason, was shot and killed by William Eddings in Canyonville, Oregon on July 26, 1883. Susan and William's descendents include many families still living near Roseburg. (Courtesy of the Cow Creek Band of Umpqua Indians.)

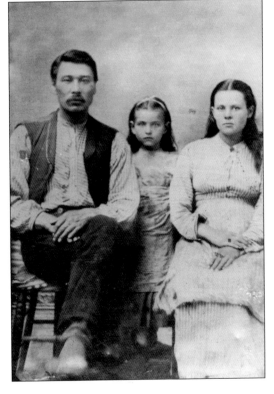

Jean Baptiste "Tom" Rondeau and his wife, Clementine Petite, are pictured with their daughter Lucinda. The couple eventually raised 15 children. They were part of the nearly 8,000 Native Americans living in the area supervised by the Roseburg Indian Agency. The agency, created in 1910, was closed in 1917 under charges of corruption. It wasn't until 1982 that a federal law was passed recognizing the Cow Creek Band of Umpqua Indians. (Courtesy of the Cow Creek Band of Umpqua Indians.)

Aaron Rose, the founder of Roseburg, was born in Ulster County, New York on June 20, 1813. His foresight and vision created the right circumstances for the town to thrive. Besides building a large home open to visitors, he helped organize many of the clubs and volunteer organizations necessary to improve the community. He died at age 86 on March 11, 1899.

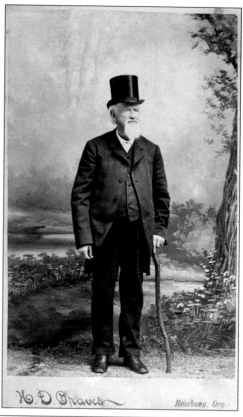

This is the oldest known photograph of downtown, probably taken about 1870. The view looks north on Jackson Street. The Metropolitan Hotel was next to the tall building in the background. The streets were dirt until 1909, and the sidewalks were plank boards. By 1878, electrical poles lined the streets and awnings were built over the sidewalks to shade the storefront windows.

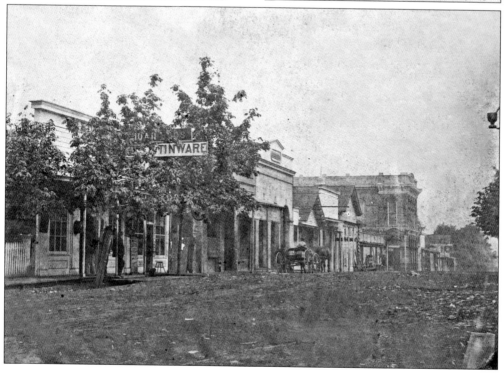

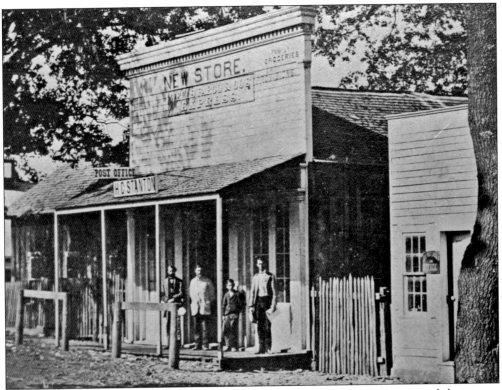

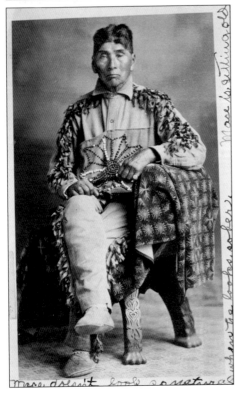

Hardy C. and Jennie Stanton erected this store and post office combination on the west side of Jackson Street between Oak and Washington Streets in 1867. The Wells Fargo Company also had an office inside. In 1874, Stanton demolished the building and erected a new brick post office. The first free mail delivery to homes and businesses began on May 13, 1891.

On September 16, 1877, Mescheck Tipton and his adopted son Mace sold 3,000 cattle for $12 a head in southeastern Oregon. It was considered to be one of the largest cattle sales ever made in the state. In 1903, Mescheck's other son, W. C., sold his 1,227-acre stock ranch 20 miles from Roseburg on the North Umpqua to George Kohlhagen for $5,000.

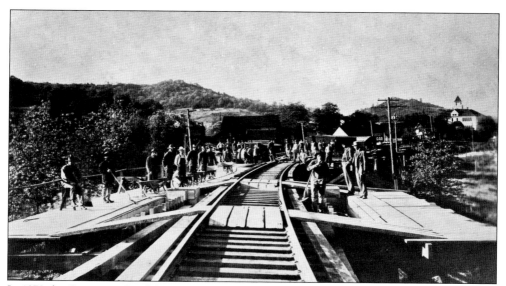

In 1872 the Oregon and California Railroad transformed the city when its railroad line ended in downtown. A roundhouse and yard were built to store and return the engines back north. This trestle, built over Deer Creek, is pictured looking south towards town. Roseburg Academy was located to the right. Irve S. Thompson was the project engineer.

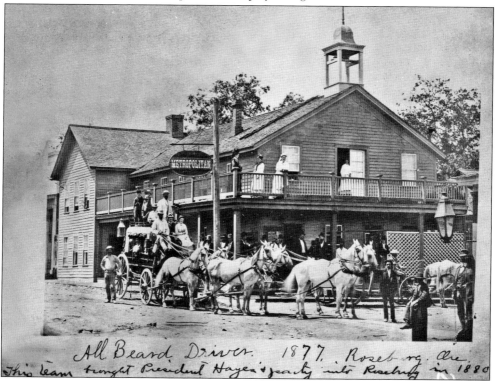

Al Beard, Driver. 1877. Roseburg Ore.
This team brought President Hayes' party into Roseburg in 1880

The Metropolitan Hotel was the first large hotel built in Roseburg. Opening for business in 1857 as the Eagle Hotel, it catered to stagecoach passengers traveling between Portland and San Francisco. It burned down in 1884, destroying nearly two blocks of downtown. Al Beard drove this six-horse team of matched horses. The Concord dead-ax stage was the most comfortable ride available.

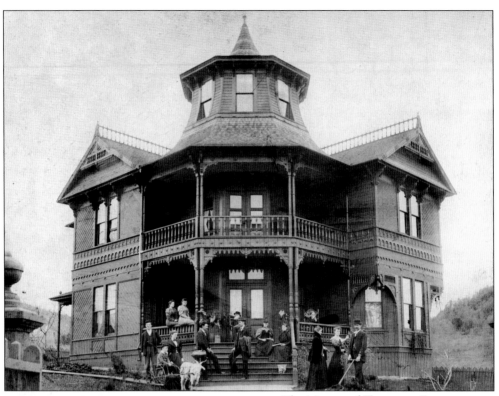

The Moses and Tennessee Parrott house was completed on September 3, 1891. Two octagonal porches decorated the exterior of the second floor. It had an octagon-shaped hall and sliding doors opening into a large parlor with an octagonal corner. Dogleg stairs in the tower led to an observatory above the five bedrooms on the second floor. The Parrott brothers had the first boot and shoe business in 1888. Today the home is privately owned.

Native American children were taken from their families and sent to reservation boarding schools by order of the federal government. These four children—Dolla, Maude, Madeline, and Lewis Thomason—were sent to the mission school near Umatilla, Oregon in 1894. As shown, the school immediately cut off their beautiful long hair, even that of the three girls. (Courtesy of the Cow Creek Band of Umpqua Indians.)

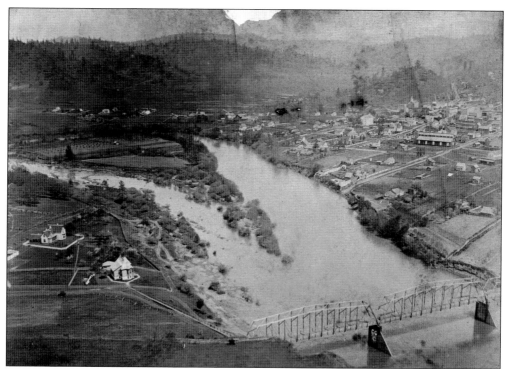

This elevated view of the valley was taken from the top of Mount Nebo in the late 1880s, showing both sides of the river and 15-acre Elk Island in the middle. The Elks Club used the island as a social center in the 1920s. The Old Lane Street Bridge was a three-span combination iron and wood truss construction built in 1884 that served Roseburg until 1972. The piers of the old bridge are still visible.

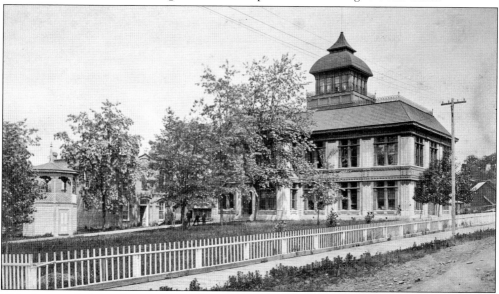

This photograph shows the county courthouse, originally built in 1870, after it was remodeled in 1890. It burned on December 18, 1898. Fortunately the county records were stored at a different site and were undamaged. To the left, behind the trees, were the brick jail and a small bandstand. The bandstand was built and dedicated in 1886. The area in front was used for celebrations and official gatherings.

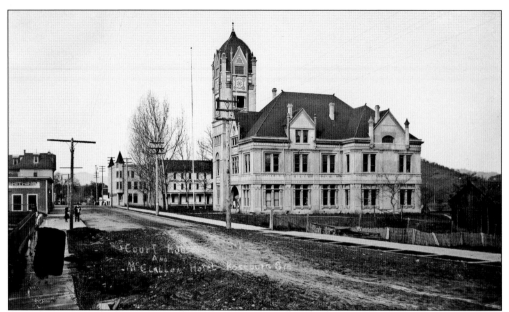

The second courthouse was built on the same site in 1899. It was a much larger building and included an impressive cupola in the front. The McClallen House Hotel was the three-story building to the left, operated by David McClallen. The new hotel addition was completed in June 22, 1888, making it the first three-story building in Roseburg. Originally it was owned by Aaron Rose and called the American Hotel.

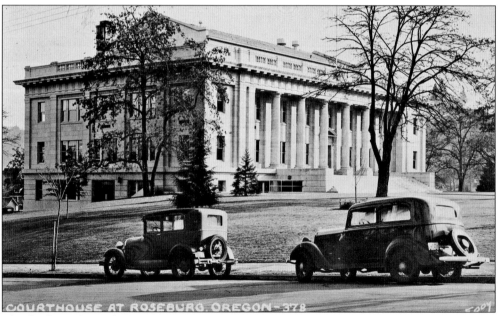

The third courthouse, built in 1929, remains today. The first floor housed the school superintendent, health department, and surveyor's office. The county court, county clerk, tax office, sheriff, and assessor were located on the second floor. The third floor included the district attorney's justice court, circuit court judge's office, and circuit court rooms. The enormous Hornbeam elm tree still present on the courthouse lawn was a gift from Sen. Binger Hermann.

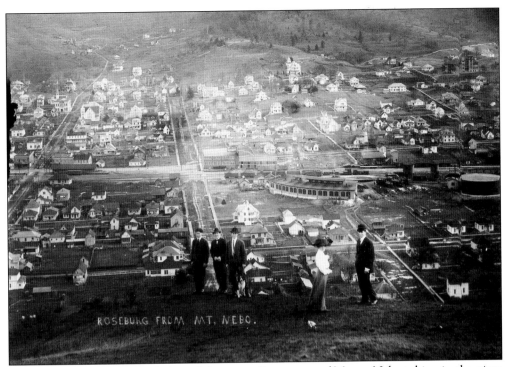

This picture from about 1910 shows hikers standing on top of Mount Nebo taking in the view. Looking down on the valley shows the wide streets laid out in blocks by Aaron Rose. Homes were sprinkled across the rolling hills. Very few trees remained near town.

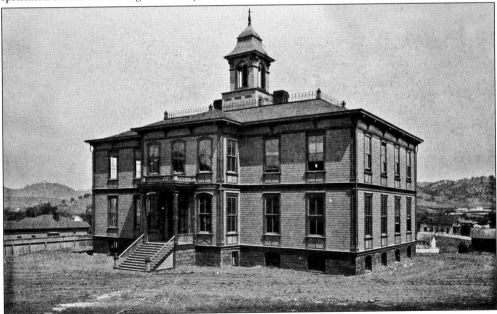

Rose Academy was the first school, and was built in 1857 on land donated by Aaron Rose between Rose and Stephens Streets on Washington Street. Due to unsafe conditions it was demolished, and Rose Public School (above) was built in 1887 on the same site. Pupils marched into classes to the beat of a drummer boy.

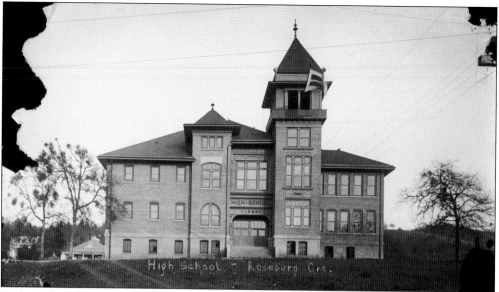

Dedicated in 1904 and named after Aaron Rose, Roseburg High School was the first high school. It was built of brick, between Hamilton and Jackson Streets and south of Orcutt Street. After a new high school was built, it became Rose Elementary School. In 1903, each of the nine graduates gave an oration and the graduating exercises were held in the Opera House. The women wore white dresses and the men black suits.

This later home of Aaron Rose, a pleasant wooden structure with several upstairs bedrooms, was located on South Jackson Street. Married three times, Rose had three daughters with his first wife, Minerva, and five children with his third wife, Frances. Two girls and a boy died young from diphtheria, and Aaron Rose Jr. died as a young man. His daughter Cora married Tom Ollivant.

Dr. Salathiel Hamilton built this mansion on Main Street for his wife Sarah and family in 1892 for $14,000. The elaborate ornamentation marked its Queen Anne architecture. At the time it was Roseburg's most impressive residence, and its four-story tower was a landmark. The house burned down in 1915 due to the inability of the fire department to secure adequate water pressure for their hoses.

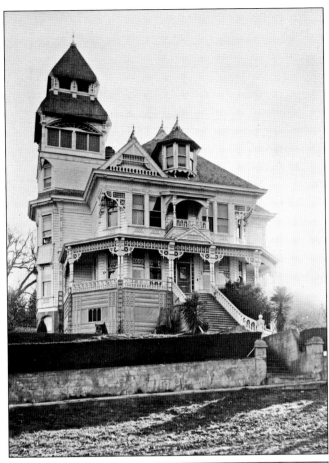

This was the second Southern Pacific Railroad depot built in 1912 at the end of Cass and Sheridan Streets. The arrival of the railroad in 1872 was an enormous boost to Roseburg's merchants. In addition to a roundhouse for turning the locomotives around to return north, the railroad built a repair facility, warehouses, and an office.

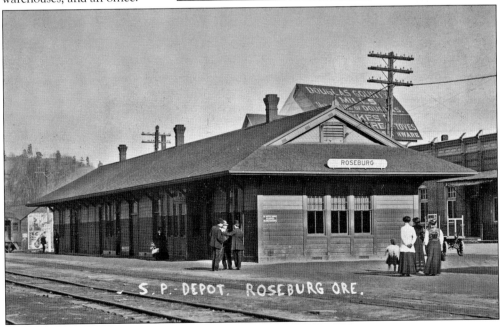

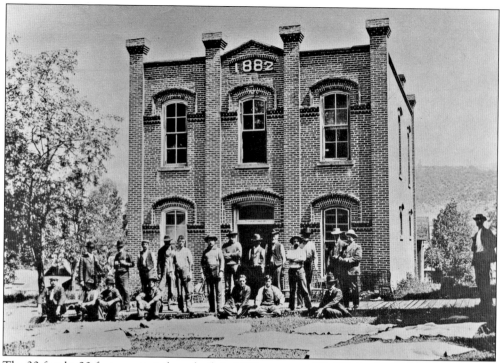

The 30-feet-by-20-feet county jail was built in 1882 at a cost of $1,800. In this picture, the inmates are enjoying the fresh air and have spread their bedding in the sun. Bedbugs and fleas were serious problems and proliferated in the straw mattresses. The jail wasn't very secure—on December 30, 1896, convicted murderer Samuel G. Brown escaped by sawing off one of the grates covering a window and was never recaptured.

The Roseburg Fire Department and City Hall was built in 1892 by J. A. Perkins, a local contractor, for $6,900. The upper story housed the firemen's room, a city council room, and the city marshal's office. The ornate roof was made of metal shingles and had a belfry for the alarm bell. In 1900 the city's volunteer firemen and city workers posed for this picture. It was destroyed in the Blast of 1959.

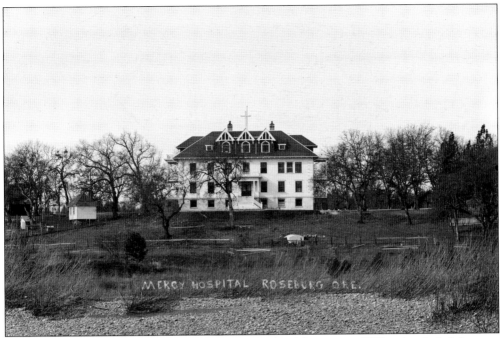

The original Mercy Hospital was built on the west side of the river in 1905 and included the most modern equipment available. The Sisters of Mercy, wearing heavy black robes with enormous headdresses, operated the 30-bed hospital. A fire in 1911 damaged the upper story and improvements were added later.

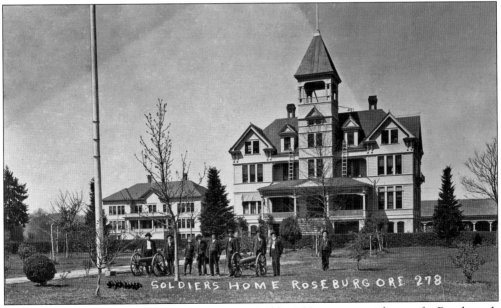

Built in 1894 for war veterans, the Oregon State Soldier's Home was a rich prize for Roseburg. It cost the state $3,000 to purchase the original 40 acres. Oregon law provided for five trustees to oversee the operation, $12,000 for the establishment, $4,000 for land, $8,000 for buildings, and an annual $12,000 for maintenance. A huge dedication sponsored by the Grand Army of the Republic (GAR) was celebrated on May 10, 1894.

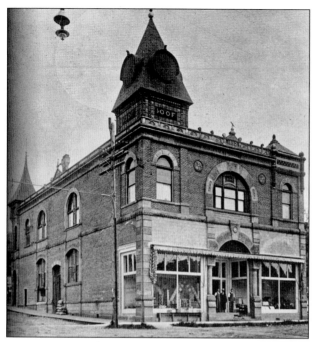

The original Odd Fellows Hall (also known as the Opera House) was built in 1892 and was located in this brick building on the southeast corner of Jackson and Cass Streets. The Opera House featured Chautauqua presentations, fights and wrestling matches, plays, and other community gatherings. Two favorite shows were the James DeMoss family, a musical group, and Buffalo Bill's Wild West Show in 1902. It underwent extensive remodeling in 1924.

Judge William R. Willis built this home between 1874 and 1880. It featured an elegant stone fireplace crafted by John Smith of Wilbur and was considered the finest residence in southern Oregon at the time. It was later moved to face south on Rose Street and used as a library and city hall. Pres. Rutherford Hayes and his wife stayed overnight in the house when they passed through the city in 1880. (Courtesy of the Roseburg Parks Department.)

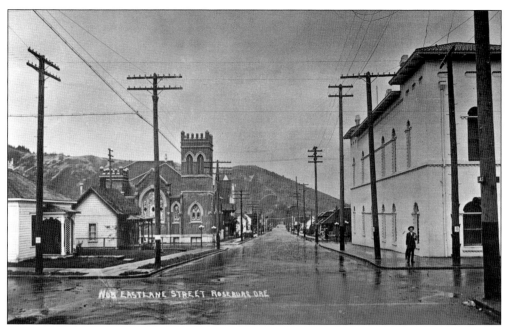

This view looked west up Lane and Main Street directly at Mount Nebo. Organized in 1873, the First Presbyterian Church is located on the corner of Lane and Jackson Streets. Rev. William A. Smick was the first minister. On the left in the rear were the Presbyterian Church and the Elks Lodge on the right.

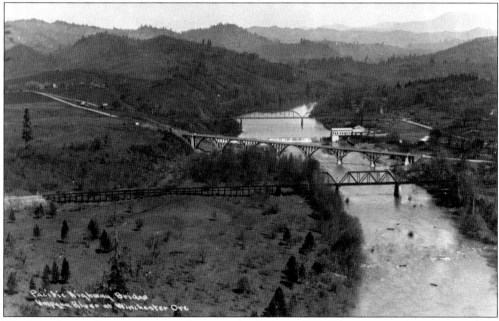

The Winchester Dam and power plant were built about 1890. This view, looking upriver from Winchester, was taken in 1924 and shows three bridges crossing the North Umpqua River 4 miles north of Roseburg. The railroad bridge is in the foreground, the Booth Bridge connecting Highway 99 is in the center, and the top bridge is the original County Bridge built in 1889. It was the first combination cantilever steel bridge in Oregon.

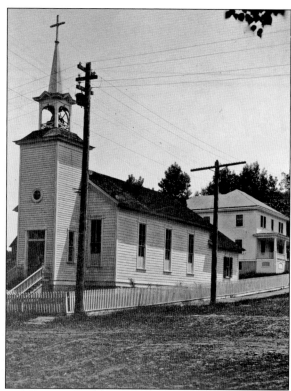

St. Joseph's Catholic Church was built and dedicated in 1887. In 1905, the church received statues of the Virgin Mary, the Holy Child, Saint Joseph, and Jesus from Paris. In 1916, a new building was erected on the same site (on the corner of Kane and Chadwick Streets). The new Stanton Street buildings were dedicated in 1968.

The Methodist Episcopal Church, pictured here, was built in 1893 and demolished in 1915. The original building was erected in 1867 on the north side of Washington Street. The congregation was established in 1852 and met at the home of John Aiken in Winchester. There was a second congregation designated the Methodist Episcopal Church North, also established in 1867. The two congregations merged in 1939 to become the First Methodist Church of Roseburg.

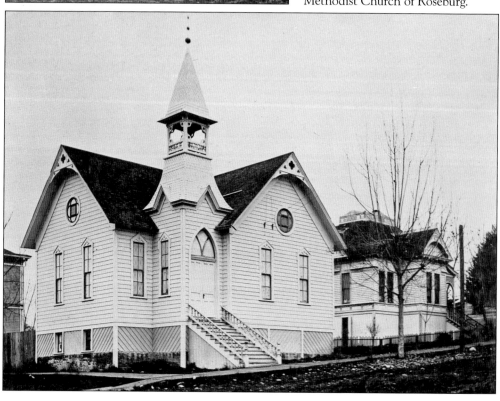

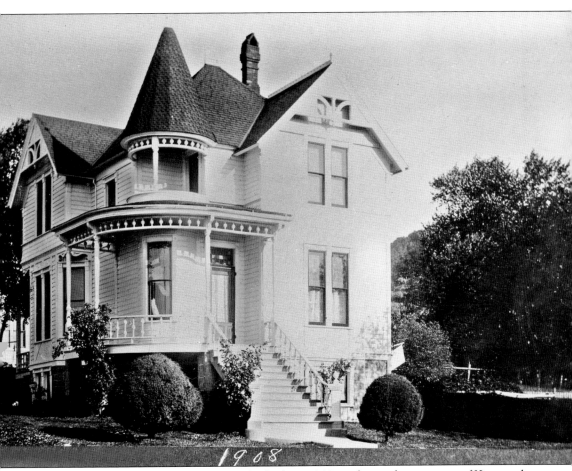

1908

The Napoleon and Annie Rice home was built about 1908 on the southeast corner of Kane and Cass Streets. Napoleon Rice was born in a Douglas County log cabin in 1859. He was the son of Ica and Martha Rice, and the brother to Dexter. He and his cousin Moses were co-owners of Rice and Rice House of Furnishings in downtown Roseburg, one of the largest furniture stores in southern Oregon in 1890. Napoleon served on the city council from 1912 to 1918 and was the mayor from 1922 to 1924. Rice Hill, north of Roseburg, is named after the family. This elaborately decorated home was only one example of many beautiful homes built before 1925. Today it has been restored and is privately owned.

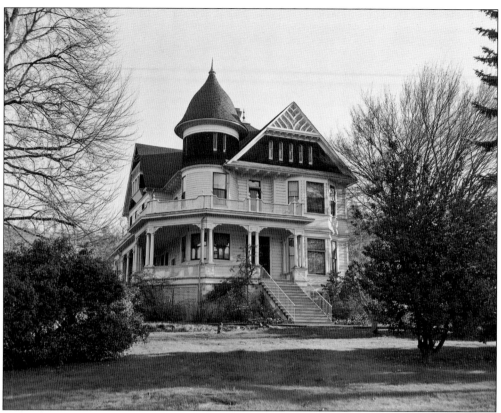

Judge James Watson Hamilton built this extravagantly ornamented Queen Anne house in 1895 on 11 acres. It had five bedrooms and a curved window seat on the stair landing in the tower. The sitting room fireplace had a hand-carved myrtle wood fireplace mantel. It was built with electricity, indoor bathrooms, and central heating. Although the home was damaged in the 1959 Blast and a later arson attempt, it still stands today.

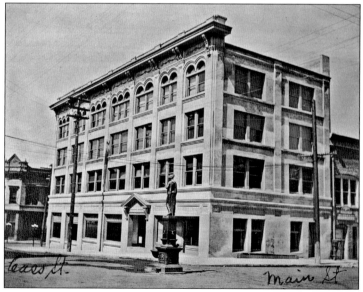

The first Masonic Hall was built in 1888 and burned in 1901. The new Masonic Hall, pictured here, was designed by architect W. A. Straw. It was built in 1909 on the northeast corner of Jackson and Cass Streets at a cost of $20,000. It was constructed of brick in an Italianate style. The lodge used the top three floors and various commercial enterprises leased the first floor.

The Hebe statue and fountain was commissioned by the Mental Culture Club and the Women's Christian Temperance Union about 1895 and installed in 1908 at the corner of Main and Cass Streets. In 1912, a horse-drawn delivery team frightened by an automobile ran out of control, knocking the statue from its pedestal and demolishing it. Today a replica of the original Hebe is displayed in the .22-acre Eagle's Park, purchased by the city in 1937 for $1.

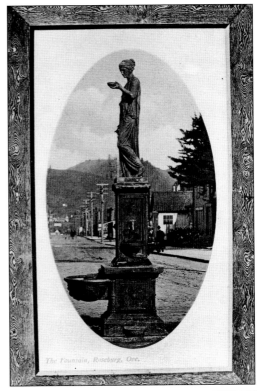

The Fountain, Roseburg, Ore.

The Marks building was built by Sol Marks in 1878 for $18,000 and stood on the corner of Jackson and Washington Streets. The first floor was remodeled into the Palace Theater in 1911, and opened with 500 seats and a classic front with stage, balcony, and organ. In 1945, it was remodeled into a cinema and renamed the Star Theater. It was severely damaged in the 1959 Blast and had to be demolished.

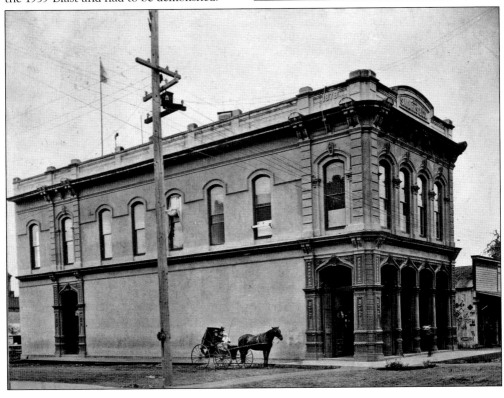

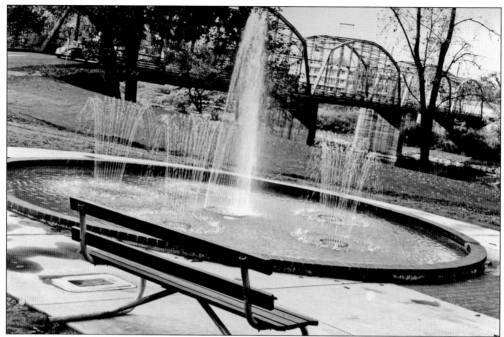

City parks were established as early as 1910. Most tended to be playground parks in neighborhoods or green areas near downtown. The largest is Stewart Park, established in 1957, and the smallest is Quintus Park, established in 1959. The fountain above was built in Riverside Park after the Blast of 1959. It graced the South Umpqua riverbank for many years until vandalism made it too costly to maintain. Today the circle is planted with annuals. (Courtesy of the Roseburg City Parks Department.)

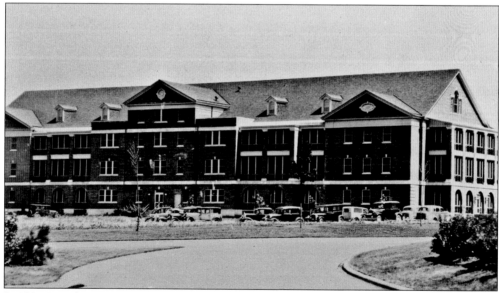

In 1931, President Hoover signed the order establishing a northwest national veterans home and hospital in Roseburg. During 1932, buildings were rapidly erected and veterans were moved into the new buildings in 1933. Approximately 80 of the 110 men in the old state home were admitted into the federal facility.

Two

COMMERCE
MAKING A LIVING

It takes many different kinds of people to help a town grow. Roseburg was blessed with generations of hard-working men and women filled with integrity and wisdom. Farmers, railroad workers, bankers, and businessmen have flocked to town over the last 155 years. Whether they stayed to raise families or wandered on to other places, they left a little of themselves behind. Some families have left four generations of names on the public school rolls. All together they made Roseburg the kind of city in which people wanted to live.

The city started with a population of 203 in 1860, and had grown to 4,924 residents by 1940. The surrounding mountains protect the valley and help create a mild climate perfect for agriculture. Farming has always been a mainstay of the county, producing prunes and turkeys in the early 1900s, and grapes and blueberries today. World War II introduced better technology and created a demand for lumber and jobs in the forests surrounding the city. In 1932, only 37 sawmills existed in the county, but by 1948 there were 278. Roseburg quickly designated itself the timber capital of the nation. Today forest management is a top concern for everyone whose job depends on logging. Lumber mills still provide jobs and opportunities for hundreds of people.

James R. Dodge Jr. and a friend are pictured here in their black wooly angora chaps. These worked better in Oregon than the plain rawhide chaps worn in other parts of the country. The wool kept the men's legs warm and protected them from the brush lining the pack train's path. Dodge, born in 1864, later worked for the railroad.

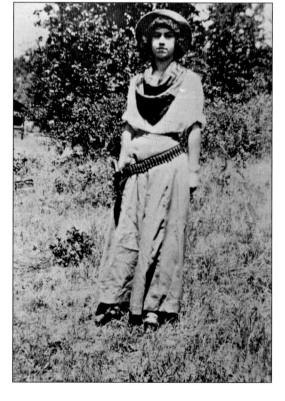

Alta V. Barager, looking ready to take on anything a man could do, was dressed in her split skirt, handkerchief, hat, and trusty six-shooter. The Barager Ranch ran cattle to pasture up the Coast Range Mountains in the spring and brought them back in the fall. Raising cattle was big business around Roseburg.

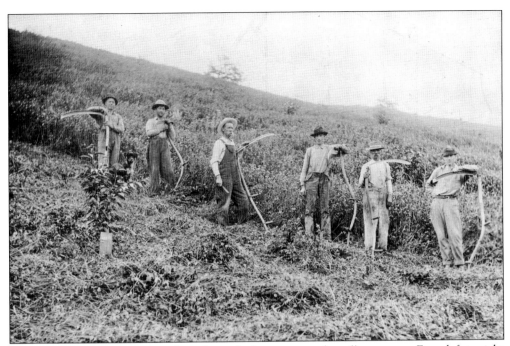

These men used scythes to cut clover hay, which grew around small pear trees. From left to right they were Ben Maddox, Tom Neal and his dog Ring, P. C. McClendon, unidentified, Charles Neal (Tom's father), and Anthony Maddox. This photograph was taken about 1908 on a hill up the east side of East Douglas Street, where Leland Avenue is now filled with homes. (Courtesy of Charlotte Long, great-granddaughter of Charles Neal.)

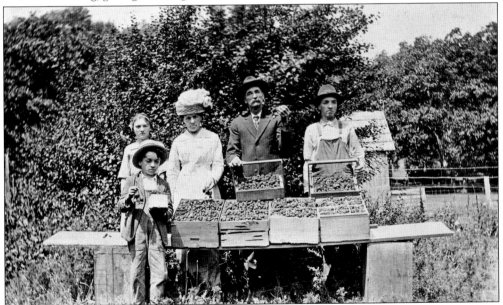

Kruse Farms has provided fresh produce for shoppers since 1923, when Bert Kruse purchased 15 acres of land, cleared it by hand, and began farming. This photograph from 1913 shows off the fresh strawberry crop from the farm on Roberts Creek. Standing behind the table from left to right are Eletha ("Babe"), Lucy, Edward, and Daly Kruse. Harold Kruse is in front.

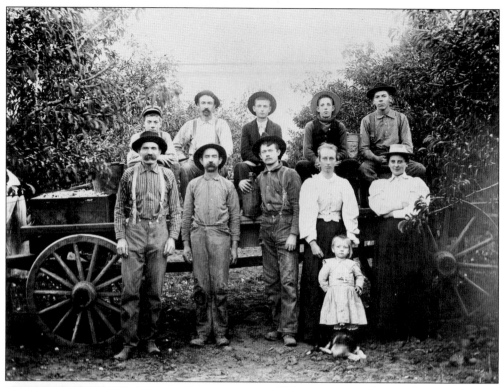

This crew was ready to pick prunes in Ab Riddle's Oakleigh Heights orchard in 1890. Charles Cook, born in 1851, was another prune farmer who established the Umpqua Valley Canning Company in 1892. The cannery, built for $12,000, had four large rooms and employed 150 people. Besides processing 1,000 bushels of prunes, it dried and canned 2,500 cans of prunes a day.

By 1932, Douglas County had approximately 10,000 acres devoted to prunes. The year 1921 was when Clarence E. Moyer arrived in town. He was a nationally recognized nurseryman of Douglas County, and developed the Moyer prune, which became one of the best selling prunes in the United States. In 1956, he was granted the Oregon Federation of Garden Clubs' annual contemporary horticultural award.

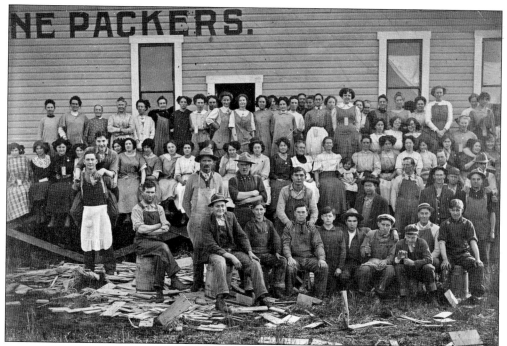

The Tillson and Company prune packing plant was opened on September 10, 1903. It was built on the railroad spur in the Kinney addition north of Deer Creek. Clarence Gazley was the manager, and Aaron Rose Jr., as the engineer, pulled the lever that started the ponderous wheels turning. On February 25, 1904, Roseburg shipped 91 carloads of dried prunes by railroad. The highest price ever paid was 22.5¢ per pound in 1919.

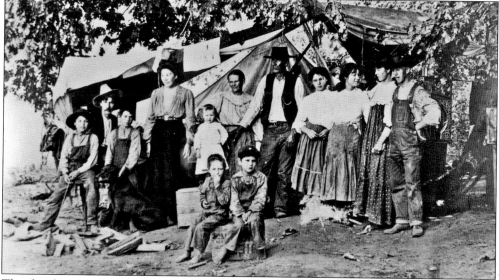

This family group is pictured at their camp during the prune harvest. The two boys seated in front are Donny Lerwill (left) and Walt Rondeau. Pictured behind them, from left to right, are Tommy Acusta, George Rondeau, Wallace Rondeau, Rose Rondeau Lerwill, Emaline Lerwill Young, Clementine Rondeau, Jean Baptiste "Tom" Rondeau, Clara Marshall, Evaline Rondeau, Francis Rondeau, and Tony Erlabach. (Courtesy of the Cow Creek Band of Umpqua Indians.)

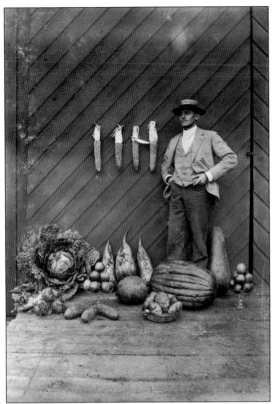

In this 1899 photograph, George Weber displays produce from his garden, including potatoes, squash, melons, and mangelwurzen. Yellow and shaped like large beets, mangelwurzen was a German import grown as a food crop. Used like potatoes, they were chopped, mashed, and boiled by the many German families living in Roseburg

Hops, an important ingredient in brewing beer, were a major crop in the late 1800s and early 1900s before Prohibition was enacted. Pictured in the photograph below were Mr. Stone, Pet Gervais, Minnie Breeser Gillam, Lucy Grubbe Sawyer, Creed Gillam, Emma Gillam Fisher McHargue, August Klinke (master brewer at the Roseburg Brewery), and Mr. Franklin.

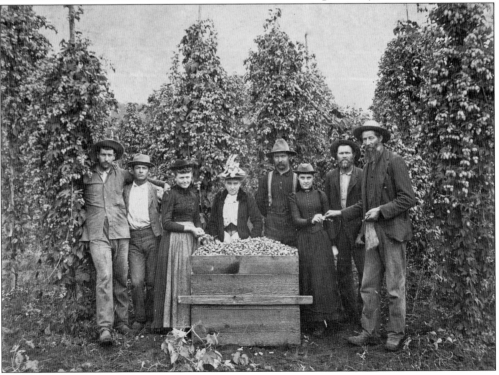

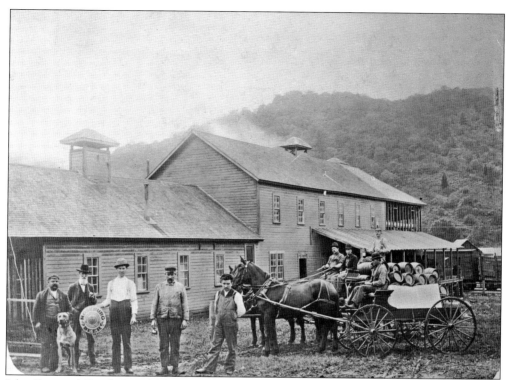

John Rast and Gottlieb Mehl built the Roseburg Brewery in 1864. They produced 15 barrels of Roseburger brand Export Beer a day in 1890, and they shipped it as far south as Ashland. The brewery also produced ice. Homes were supplied with large squares of cardboard with different numbers of pounds written on them. To purchase ice, the family posted the square with the correct number of pounds in a window.

Max Weiss purchased the Roseburg Brewing and Ice Company in 1898. During Prohibition, his main product was ice, which was a luxury before that time. This photograph was taken about 1905 and shows, from left to right, Tony Mertz (brewery wagon driver), Adolf Ospald, Joseph Heindenreich, Albert Weiss (son of Max), and Max Weiss, the owner.

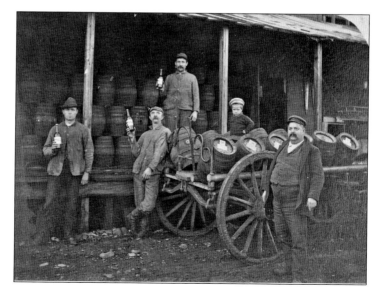

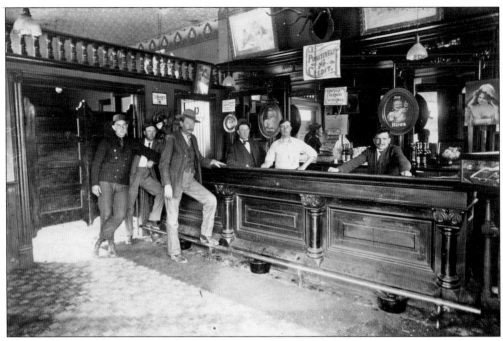

The Imperial Saloon, located on the northeast corner of Cass and Sheridan Streets, was one of the fancier drinking establishments in town. In this 1911 photograph, Fritz Stauffer is pictured at the far right, and Joe Barthalmy was third from the right. Also pictured were William Moore and Elmer Staley. Two men are unidentified. On April 16, 1903, Ed Bridges bit off Bud Thomas's finger in an argument over a game of 21.

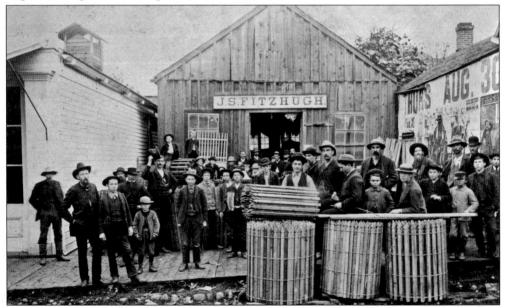

In 1866, Joseph S. Fitzhugh arrived in Roseburg and became postmaster in 1867. Later he established this picket fence plant named J. S. Fitzhugh Manufacturer. This picture shows the men employed at the plant. He served two terms as city mayor, several terms on the city council, and was elected county judge in 1870. He married Mary J. Flowers and raised three sons.

The Roseburg Soda Works was located on the corner of Oak and Pine Streets near the railroad tracks. In May 1913, the company decorated this float for the Strawberry Carnival. Ernest T. Unrath, owner, and William, his son, were on the wagon. Elise M. Wettstein (left) and Marie E. Unrath were on the sidewalk. The two boys on the right were unidentified. William was killed in the Blast of 1959.

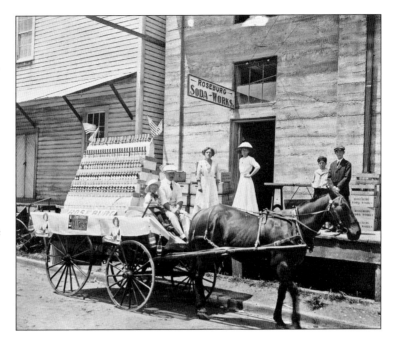

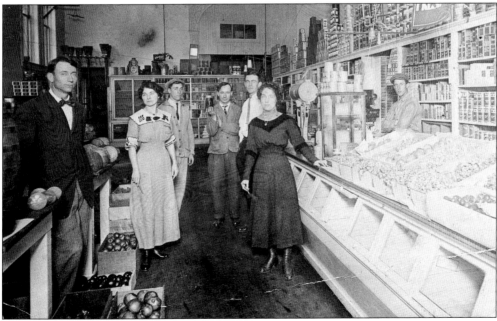

This picture shows Agnes MacIver in a typical Roseburg grocery store around 1915. In 1914, the following prices were advertised: 50¢ for 10 pounds of oatmeal, a five-pound box of fancy crackers, or 10 bars of white soap; 60¢ for one pound of imperial tea; $1 for three pounds of steel-cut coffee or 13 pounds of sugar, and $1.60 for a 50-pound sack of flour.

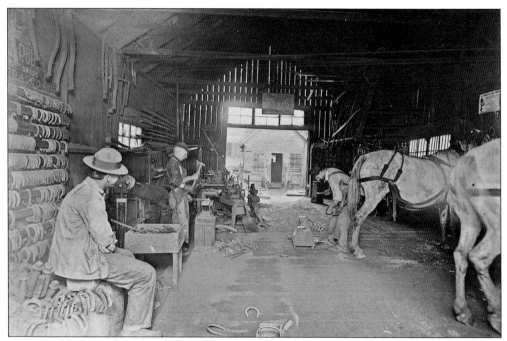

About 1911, George Poole (at the anvil) arrived from Mt. Vernon, Maine and opened this blacksmith shop. It was located on Jackson Street until 1916, when he moved to Rose Street. He did all types of smith work in his shop.

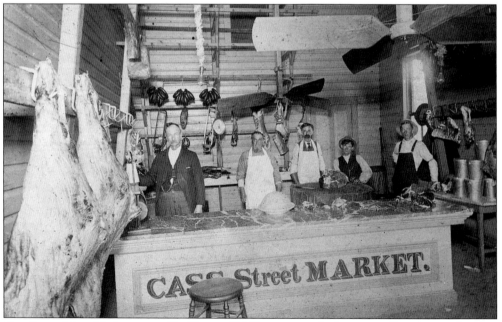

Cass Street Meat Market, owned by George Kohlhagen, was the largest and best-known butcher shop in 1898. From left to right are an unidentified man, Jake Bitzer, A. J. Beckley, George Howard Hess, and Johnnie Beckley. At Thanksgiving, turkeys were hung up by their necks on a rack and picked clean of feathers, with the entrails left inside. Kohlhagen eventually owned several ranches with sheep and cattle.

Ica F. and Martha Rice and their son Dexter owned the Rice and Son Butcher Shop on the corner of Cass and Jackson Streets. In this 1891 picture, 10 deer were brought back from a hunting expedition and offered for sale. Dexter became an attorney and was county judge in 1913. He later served in the state legislature and as state game commissioner.

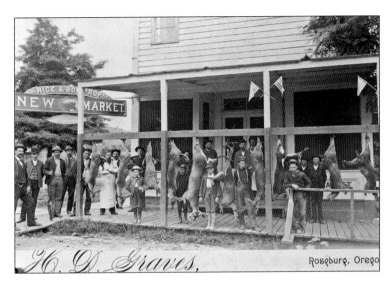

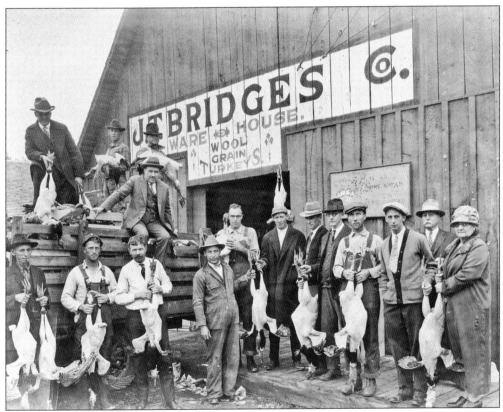

Turkeys were a major export during the early 1900s. These dressed turkeys were ready for shipment from the Joseph T. Bridges Warehouse near Oakland. Pictured standing from left to right were Wally Freyer, Ruel Gray, Tom Harvey, Alfred Hand, Walter "Turk" Manning, Henry Denley, Harvey Mahoney, unidentified, Alva Copeland, R. D. Bridges, Fred Whitmore, and Belle Bridges. Dr. S. C. Endicott, Art Denny, and A. A. Darby are standing on the truck from left to right. An unidentified man was seated.

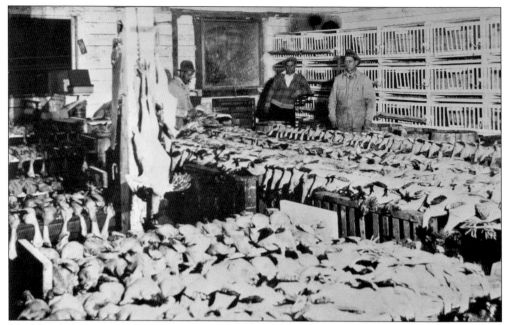

The Plaindealer reported on December 6, 1902, that nearly 11,000 turkeys had been shipped from Douglas County that year. Plant workers earned 5¢ per bird to pluck feathers. Live birds sold for 17¢ a pound. Ray Rauch owned this poultry plant at one time, buying and selling chickens, eggs, and turkeys. They also slaughtered and plucked chickens and turkeys for customers. In 1938, 900,000 turkeys were shipped out.

Phillip Benedick is standing in front of his 1910 cabinet shop. Benedick is in the center between Britt Nicholas (left) and Jim Buchanan. He also established a prosperous undertaking business, which he sold to William B. Hammitt in 1903.

40

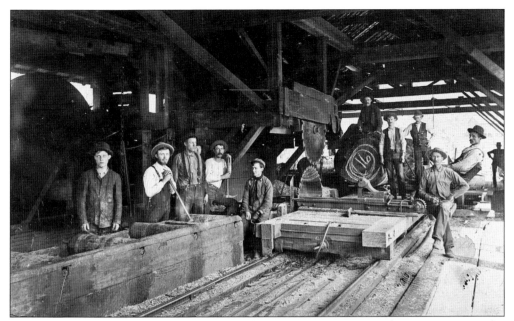

This is an interior view of the J. J. Jones Lumber Company in 1897. It shows carriage circular saws of the head rig. The men were identified as Jack Lewis (on top of the log), John Kelly, Jack Magladry, Harry Jarret, Bill Hart, and Gus Heinrich. It later became the Booth-Kelly Lumber Company. In April 1905, the owner, Robert Booth, was under investigation for fraud.

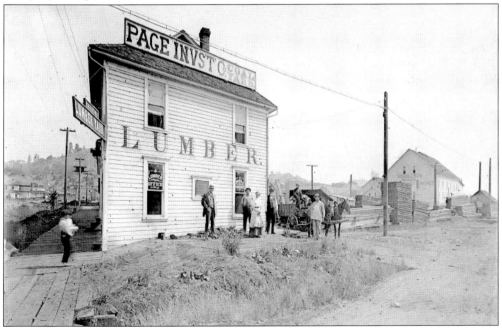

The Page Investment Company Lumber and Coal Yard was located at 700 N. Jackson Street. Taken about 1915, this photograph showed from left to right: Elisha B. Page, Carlos M. Page, Margaret A. Page, and Elisha W. Page. Will Sebring was seated in the wagon and William Grounds was standing in front of the horses. Elisha W. was president and his daughter Margaret was secretary. To the right was the H. S. Gile and Company Prune Packing Plant.

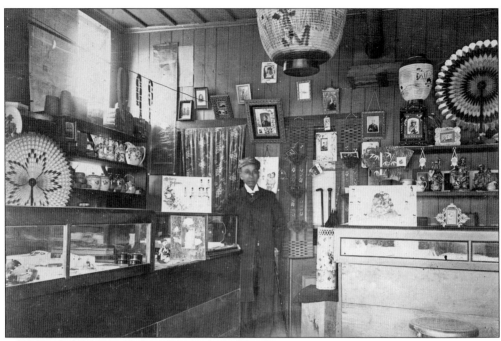

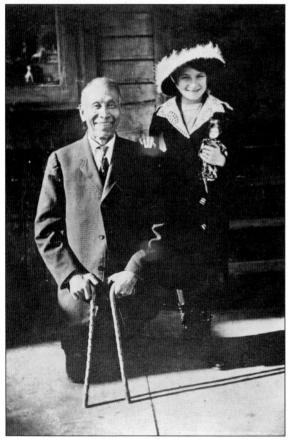

Yung Sam arrived in Roseburg at the age of 29 in 1866. In 1896 he opened a small store called China Sam's Bazaar on the west side of Jackson Street between Douglas and Washington Streets. In it he sold firecrackers, silk handkerchiefs, flags, dolls, and many other things made in China. The entrance had 10 to 15 steps leading up to the narrow building with its high-pitched roof. A black curtain marked off his residence in the back of the store. A misguided treatment led to the amputation in 1901 of his legs below the knees, and he spent the rest of his life using canes to get around. He loved to have his picture taken with children, and is seen here with Wanda Russell in front of his store. He died on April 6, 1931.

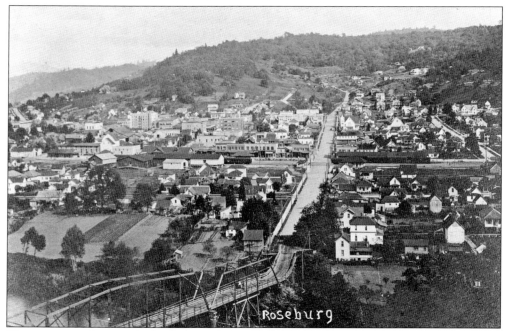

This panorama photograph clearly shows the streets, homes, and businesses of downtown Roseburg. It was probably taken from the top of Mount Nebo in 1905. The old Lane Street Bridge, built in 1884, runs through the center of town perpendicular to the railroad. Electric poles line the unpaved streets.

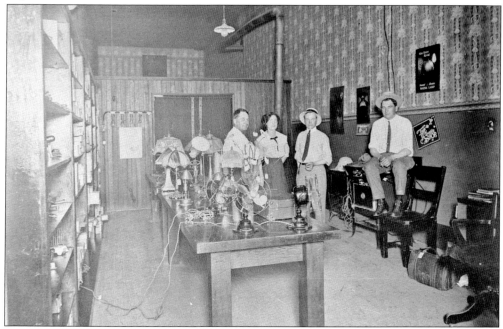

November 5, 1891, marked the date 10 electric lights were turned on in downtown using a Thompson-Houston generator with a 75 horsepower engine. Before that, James Moore was paid $19.50 a month to light the city's kerosene lamps each night. This was an early electrical shop about 1910, where Agnes MacIver (second from left) worked as the bookkeeper.

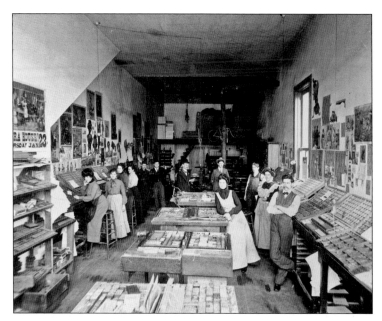

Gaius Webster purchased the *Ensign Review* in 1868 before becoming state senator. The employees, pictured from left to right at the office in January 1903, were Ona Slofrer, Lillian Criteser, Della Brown, Cora Wimberly, M. Fickle, Louie Reizenstein, Lee Wimberly, Elmer Wimberly, John Ryan, Emma Fisher, and B. W. Bates. Ellen Crabtree was standing in the center.

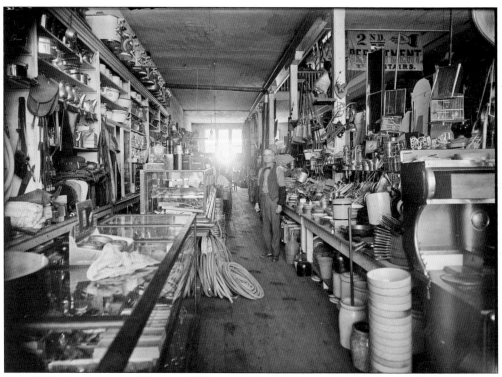

John Gildersleeve, pictured here in 1888, owned this furniture store on the northwest corner of Jackson and Douglas Streets. He carried an extensive stock of furniture, from kitchen supplies to parlor and bedroom sets of black walnut, cherry, oak, and ash. Plain or upholstered easy chairs, sofas, and lounges were also sold. In 1890, Napoleon and Moses Rice opened the Rice and Rice House of Furnishings.

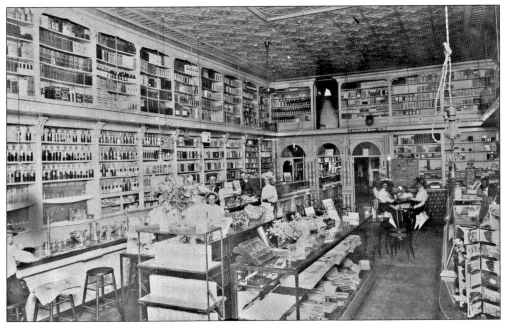

The Hamilton Drug Store, established in 1856 by Dr. Salathiel Hamilton, was the town's earliest pharmacy, and housed the telegraph office. In 1886, Hamilton was joined by his two sons, Walter S. and L. H. In 1890, the business moved to 241 Jackson Street, where it remained for many years. They sold homemade ice cream for 50¢ a quart. Cones were 5¢ and sodas were 15¢.

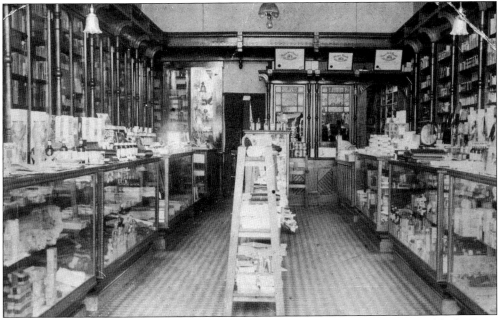

In 1888, Alva C. Marsters had a drug store in the middle of the Jackson Street block. Ernie Applewhite was the pharmacist, and his assistant was Fred Russell. Their barometer was used by the city to forecast the weather. Marsters eventually organized the Roseburg National Bank in 1907, which was one of the few banks to survive the Depression intact. Marsters was a state senator, pharmacist, and two-term mayor of Roseburg.

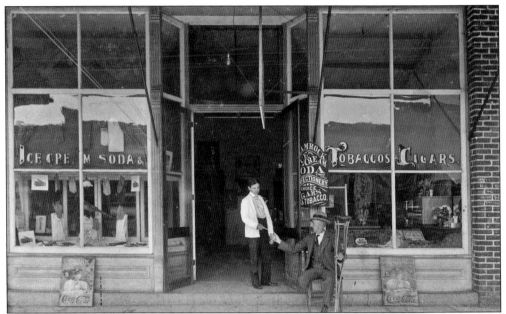

On March 20, 1902, experienced cigar makers J. A. and Thomas Cobb began the manufacture of cigars in Roseburg. Their main room was in Hendrick's brick building near the depot, formerly occupied by Bayless and Starmer's Roseburg Café. Wilbur Ross, the clerk, is pictured on the left and Mike DeVaney is seated. DeVany was a Southern Pacific engineer who lost his leg in an 1899 train wreck.

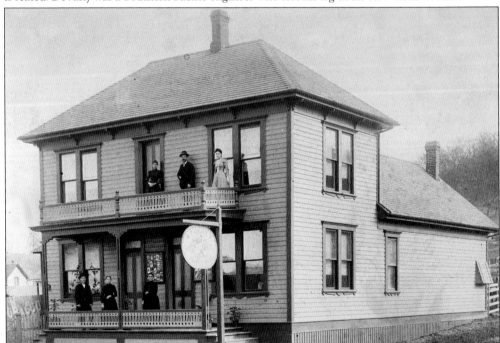

Hubert D. Graves began his photography business on September 1, 1887, and sold it in July 1903. He returned a year later, and worked for four more years. His studio was located at the corner of Cass and Jackson Streets until 1908, when it was moved to make room for the Masonic building. Many of the photographs in this book were part of the Graves collection.

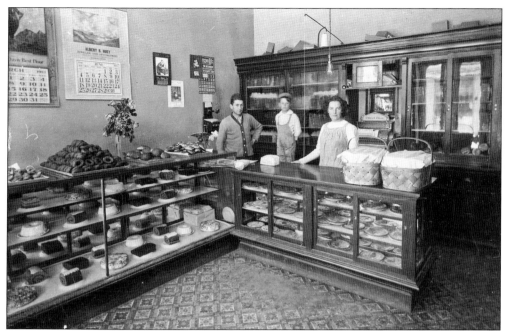

Pictured here in 1911 is the Church Brothers Bakery. It was located on the corner of Jackson and Cass Streets and owned by Howard B. and Milton Church. The display cases show cakes, pies, bread, rolls, and pastries. Pictured from left to right are Howard Church, his son Clarence, and Ella Cavey. In 1916, Howard heroically went into the burning high school and saved hundreds of dollars in equipment.

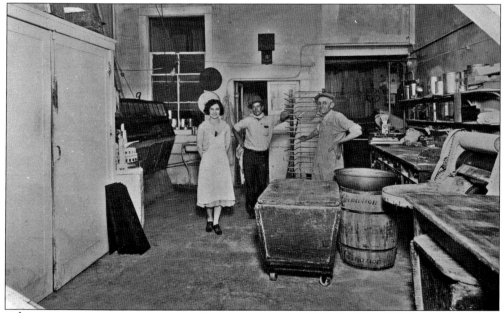

George Weber stands on the right in this 1932 photograph of Weber Brothers Bakery. The bakery was originally opened in 1917 by August Heck. Maurice and Henry Weber (sons of George) purchased it in 1909. They operated the bakery until December 1940 when they sold it. Employees worked 12 hours a day, six days a week, and earned $5–$10 weekly.

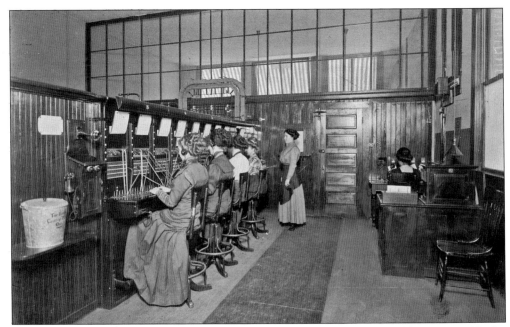

Hardy Stanton installed the first telephone in town between his store and home in 1887. On November 27, 1890, the Portland Telephone and Telegraph Company installed telephones in Roseburg homes for $20 and charged a service fee of $5 a month. The telephone lines were connected to California on October 17, 1898, and night service began on March 1, 1900. This 1905 photograph shows supervisor Iva Blanch McAllister Chenoweth standing behind five operators.

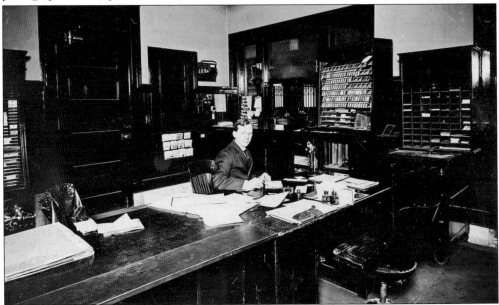

The oldest telegraph office in Oregon was established in May 1864. The office was built in a corner of Dr. Hamilton's pharmacy, where it stayed for the next 25 years. Hamilton was the appointed operator. In 1890, it was purchased by the Western Union Company and moved to another building. This photograph, taken in 1910, shows Wendell Wright, the Southern Pacific telegraph agent.

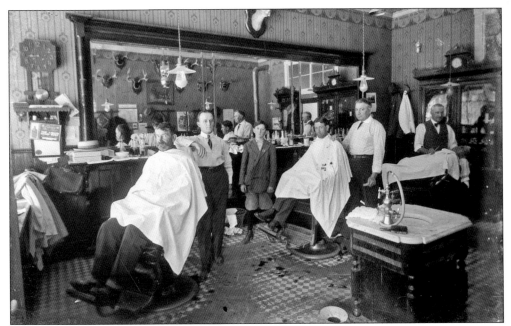

Luther J. "Lather" Barnes owned this barbershop on Jackson Street in 1911, next to the First National Bank. There were two bathrooms in the back fitted with elegant porcelain bathtubs. Charles Beck, from Chicago, was Barnes's assistant. In 1901, F. H. Woodruff opened a modern barbershop on Jackson Street in the former storeroom of Kruse and Newland.

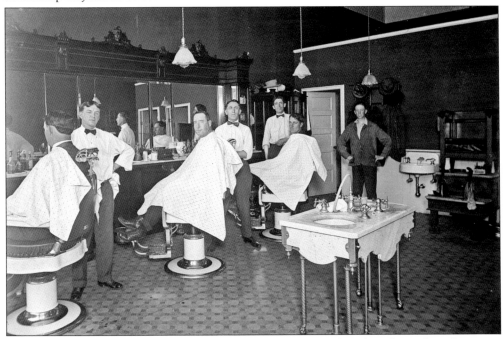

This 1909 photograph shows the interior of the Chenoweth Barber Shop, located on the corner of Cass and Sheridan Streets. Harrison Chenoweth, standing on the left, was the shop's first barber. The rest were unidentified. Many men had a daily appointment with the local barber to get a shave with a straightedge razor.

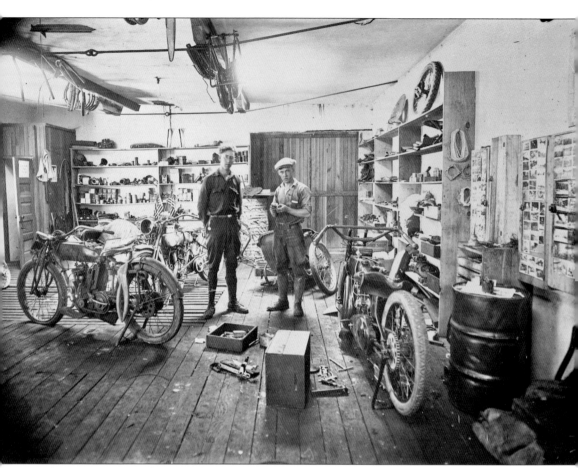

This was a motorcycle repair shop in July 1924. Roseburg's first motorcycles were serviced and sold from here. In 1915, a motorcyclist was hired by the city to catch speeders going over 15 miles per hour. Motorcycle races were popular events at the annual Strawberry Carnivals. In 1947, the police department purchased a brand new Harley-Davidson, and patrolman Bob Tracy apprehended a drunk driver two hours after he started riding the machine. Within a few weeks, fines from traffic violations nearly paid for the motorcycle. By 1950, the police department had two motorcycles, two cars, and eleven officers.

Roseburg has been blessed with many fine physicians. Dr. Woodruff was a physician in 1878, with an office located in the drug store opposite the Roseburg post office. In 1892, all physicians were warned they would be arrested if they drove faster than six miles per hour through town. Dr. W. H. Taylor, another fine Roseburg physician, is pictured in 1911 sitting at the desk in his office at 343 North Main Street.

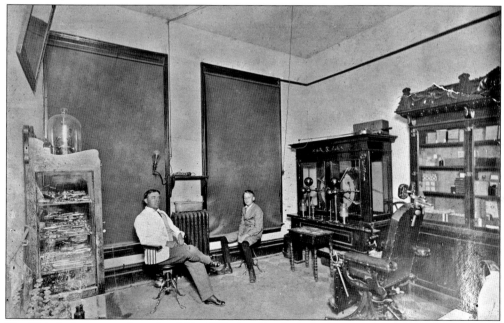

The Plaindealer reported on April 21, 1905, that Dr. A. S. Seely was taking over the practice of Dr. Charles Fisher. Dr. Seely was a prominent physician and surgeon with an office in the old Pacific building on Cass Street. Shown here was Dr. A. S. Seely and his son Hal. The photograph shows his office and examination chair around 1915.

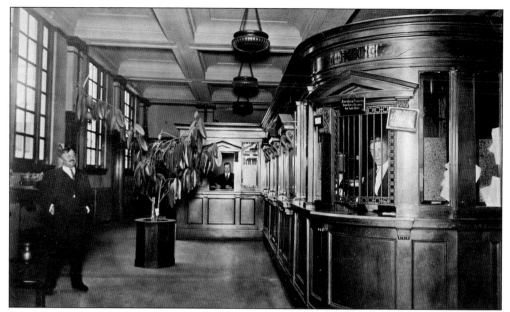

The Roseburg First State and Savings Bank was built in 1910 on the southeast corner of Oak and Jackson Streets. From right to left inside the teller cage are bank president Joseph Micelli, his son Victor, and Joseph Heidenreich. Micelli came to Roseburg in 1890, and served as mayor in 1911. He also owned a brickyard, which shipped nearly a million bricks a year to coastal markets.

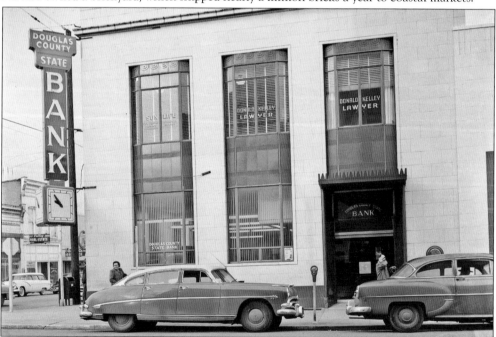

In 1925, Thomas Benton Garrison married Gertrude Young. After establishing a bank in Oakland, the couple moved to Roseburg in 1945 and built the Douglas County State Bank. Thomas was the major stockholder and president until 1954, when his son L. Earl Garrison took over his position. The bank supported Roseburg's timber boom after World War II, and merged with the First National Bank in 1965. Earl's son Thomas and grandson Judge Randy Garrison still work and live in the city.

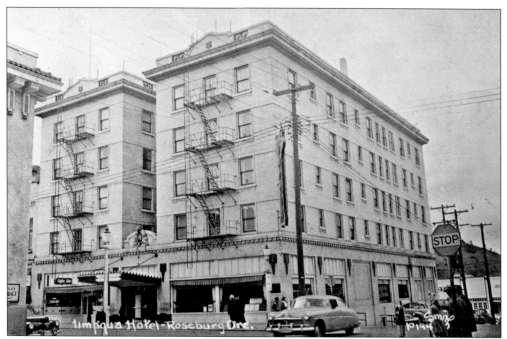

The Umpqua Hotel, the largest hotel in town, was built in 1913 on the southwest corner of Jackson and Oak Streets. It had 5 floors, 112 rooms, and 12 apartments. A nightclub called the Indian Room was situated on the first floor and had a statue of a Native American chief over the entrance. The club served bootleg whiskey during Prohibition, in the days of flappers, sheiks, and rotgut whiskey. It was severely damaged in the 1959 Blast and burned in 1974.

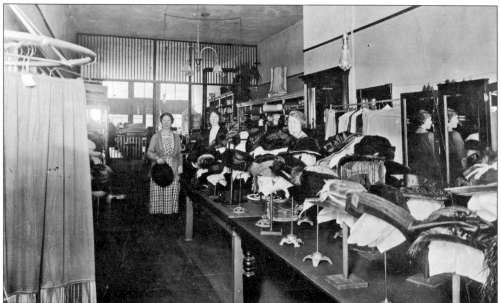

This 1920 photograph shows the interior of Minnie and Mineta Bell's dress and hat shop, which was located in the block between Cass and Rose Street. At the far right was Phoebe Hoag Roady, a clerk in the shop. Bethenia Owens also ran a millinery shop in Roseburg on the southwest corner of Jackson and Douglas Streets next to the millinery shop of Ann Compton.

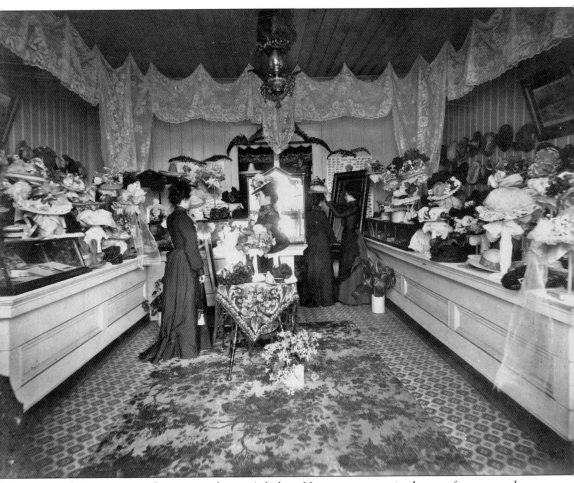

Hat shops were popular among the city's ladies. Hats were a required part of every outdoor ensemble—the fancier, the better. Every newspaper illustration showed elegant ladies with enormous hats balanced on their heads. A particularly fancy hat could cost $10.

The Roseburg Chamber of Commerce had its origins in 1908 when it was decided the city needed a booster club. This photograph from 1940 shows members pictured from left to right: Harry Pargeter, president of the Kiwanis; W. C. Harding, secretary of the chamber; W. W. Goodwin, president of the Lions Club; Bruce Mellis, president of the Rotary Club; L. W. Weisenburger; and V. M. Orr, president of the chamber.

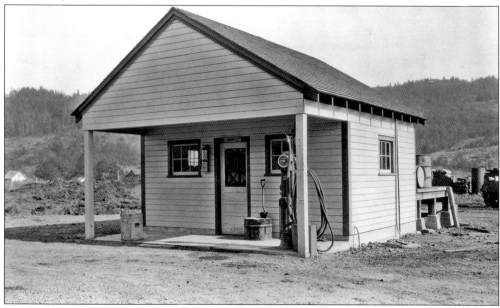

In 1933, the federal government initiated the National Industrial Recovery Act, and the Umpqua National Forest organization arrived. Within a couple of years, four buildings were erected and forestry became big business. This 366-square-foot gas house was built in 1935 to service forestry vehicles. After World War II, lumber demand boomed and Roseburg was located in the center of 5,000 square miles of hills and valleys, 20 percent of which was classified as timber.

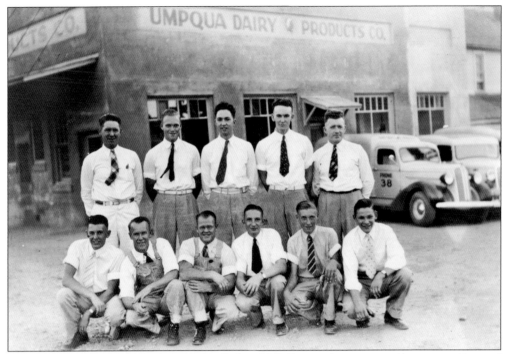

Umpqua Dairy was established in 1931 by Herbert V. Sullivan, who was joined by partner Ormand Feldkamp in 1933. The 1934 crew was from left to right: (front row) Sam Thompson, Colton Beacroft, Ira Kinagy, Milton Keller, Ed Nelson, and Shirly McLaughlin; (back row) Ormand Feldkamp, Lloyd Nelson, Harvey Miller, Phil Wassom, and Herbert Sullivan. Their first delivery vehicle was a 1929 Hudson. (Courtesy of the Umpqua Dairy.)

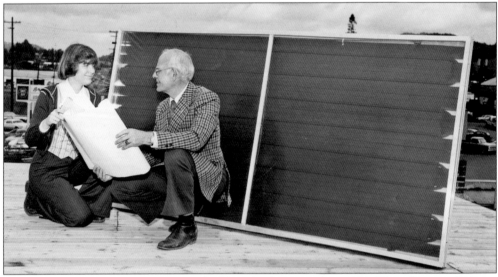

Sims Electric was the first company to build a solar heat panel, in 1972. This photograph shows the owner, Ray Sims, posing with his 18-year-old daughter Marcia beside the installation. That same year they installed four separate panels on roofs in Roseburg, including one for the public Hawthorne pool. The collector supplemented the regular heat system and paid for itself in four years. The pool exists today under private ownership. (Courtesy of Ray Sims.)

Three

AFTER WORK
PLAYS, PARADES, AND CLUBS

Social activities have provided the glue holding Roseburg residents together for the last 155 years. Fraternal and volunteer organizations banded together to provide a growing city's necessities. Clubs provided entertainment, civic improvement, and education. Masked balls were popular ways to earn money for fire equipment and churches. The Strawberry Carnivals held in the early 1900s were incredible three-day celebrations showcasing the town's agriculture industry and public spirit. Roseburg was part of the Chautauqua circuit and welcomed many speakers and entertainers to the city's opera house. Churches, clubs, and interest groups performed plays and talent exhibitions. Traveling circus companies came through on a regular schedule, bringing live animals and exotic performers.

Play is a fundamental part of the human spirit, and Roseburg has an abundance of opportunities for such in the rivers, national forests, and city parks. Today the city is celebrated for the Douglas County Fair, Graffiti Weekend, and Music on the Half Shell, a summer concert series. Camping, hiking, and swimming are still part of Roseburg's expanding opportunities for fun. There is something or someplace nearby for everyone to enjoy.

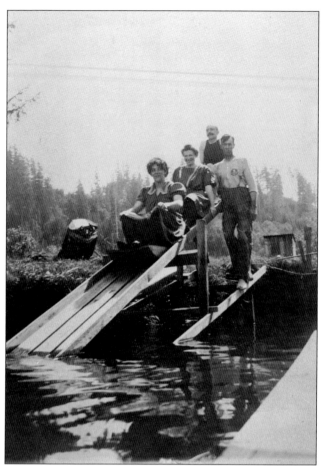

With the river so close to town, swimming was a popular activity for everyone. People's inventiveness never ceases and in this case, slides or "chutes," were built at various places on the river to add a little excitement to the old swimming hole. Louis Seymour built these chutes. Pictured from left to right were Janet Davidson, Nora Seymour, Louis Seymour, and Bert Melvin.

In the winter the river provided another kind of sport. In January 1888, the temperature dropped to six degrees below zero, and the South Umpqua River froze over. In the 1920s the river froze again, allowing Ernest Unrath and the children pictured below to ice skate below the Old Soldiers Home. Ice blocks were cut from the river, covered with sawdust and stored in warehouses for commercial and home use.

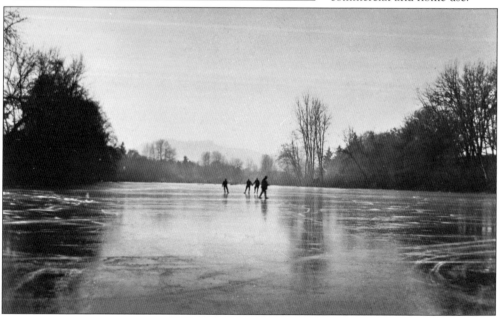

Young children were often the subjects of photographs taken in studios. This 1910 photograph of Mildred and Eliza Church was unusual, as it was taken outside with a natural stump behind them. In the 1800s, having a photograph made was usually a once in-a-lifetime event and was taken very seriously—not only for the expense, but for the sentimental value to the family.

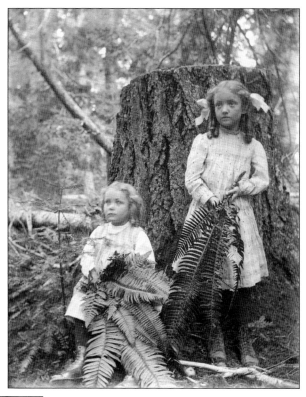

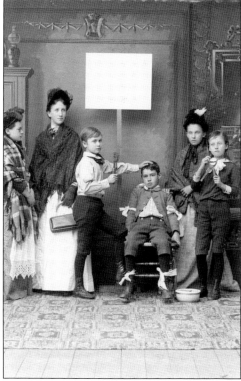

These six children were dressed and posed in a photography studio as a spoof on the dental experience in the late 1800s. The sign reads, "Phillip and James Dentists." The victim was tied hand and foot to the chair and the observers were dressed as adults in shawls and aprons.

People living in the country viewed a trip to town as a major event. Margaret Bacon Hannum (left), Mell Bacon Leatherwood (center), and May Winifred Humphreys lived in the Garden Valley area and came to town for the Strawberry Carnival in 1912. These young friends decided to buy new hats and have their photograph taken.

The women in the buggy were from the Chicago Symphony Orchestra, and arrived in Roseburg as part of the Chautauqua circuit. From 1894 to 1920 they traveled from city to city, bringing culture to the rural areas of America. Frank Alley was driving the wagon on Douglas Street. The McClallen House hotel was in the rear.

Florence McHenry had her fifth birthday party on July 7, 1900. The children in attendance were, from left to right: (first row) Sybil Gibson, Hazel Drennen, Aileen Townsend, Floy Houston, and Hellen Jane Hamilton; (second row) Helen Wollenberg, Lenore Dale Coshow, Fay Abraham, Bernie Abraham, Merle Hamilton, and Gladys Strong; (third row) Dorothy Dugas, Irma Wollenberg, Vesta Kruse, Capitola Willis, Mary Townsend, Leah Pitchford, Irma Clements, Dorothy Godfrey, and Margaret "Maggie" McClallen; (fourth row) Marjorie Carlon, Florence McHenry, Greta Kohlhagen, and Ruth Patterson.

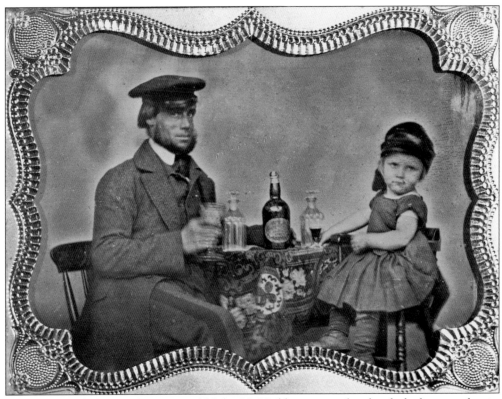

Capt. Jack Nicholson and two-year-old John N. Hedden enjoy a bottle of whiskey together in 1858. Nicholson was the captain of a river steamboat that cruised up and down the headwaters of the Umpqua River. John Hedden was born in Scottsburg on May 1, 1856. He operated a general merchandise store and lived his whole life in Douglas County.

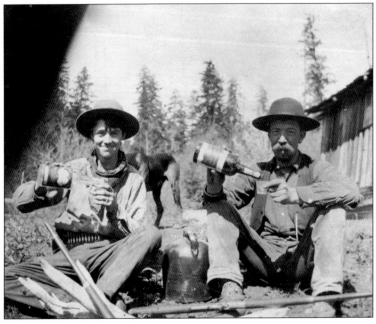

Charles Collins (left) and Charles Parazoo enjoy a jug and bottles of liquid libation after a long day's work. Both men worked as packers hauling supplies from Roseburg to the many small towns and settlements of southern Oregon. Alcohol was a necessary staple to successful merchants in the 1800s.

Floyd (left), Clarence (center), and Ralph Church are dressed as cowboys with hats, ropes, and kerchiefs in this 1911 Clark Photography Studio picture. These tough cowboys seem to be missing their boots.

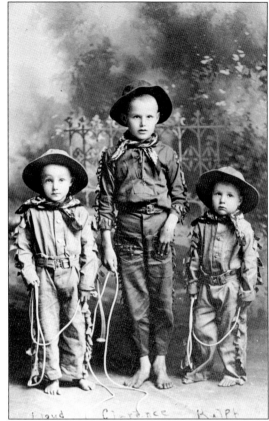

George and Effie Weber immigrated from Germany in 1893. This picture taken outside their home in 1903 shows five children playing on their toys—a metal tricycle and a wooden rocking horse. The children are, from left to right, Maurice Weber on the rocking horse, Cora Weber, Ernest Weber, Avis Stephens (seated), and Alfred Stephens on the tricycle.

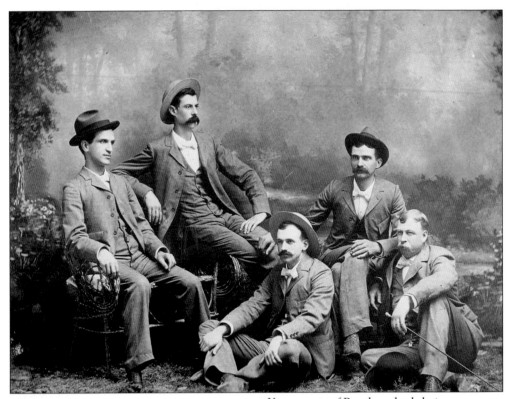

Young men of Roseburg had their own social clubs. In 1889, these members named their group the "Gay Blades." Sitting in chairs from left to right are Herman Marks, Fred Zigler, and Eugene Parrott. Sitting on the grass are Fred Haines (left) and Louis A. Sanctuary. Parrott was the Douglas County sheriff from 1900 to 1904.

Link Rice (left) and Henry Sawyer pose in this studio photograph from about 1870. Besides organized card clubs, informal games of chance were popular in local saloons and in various homes. The Cinch Card Club was a men's social group that met to enjoy cards and alcoholic libations.

Girls participated in organized sports just as boys did. This photograph shows the Roseburg High School girls basketball team before a game in Corvallis on February 5, 1903. Pictured here from left to right are: (first row) Vell Barker, Ella Black, and Willeth Reed; (second row) Neta Cavot, Edna Parsley, Squee Ramp (assistant manager), Tom Townsend (manager), Vivian Jewett, and Gertrude Rast.

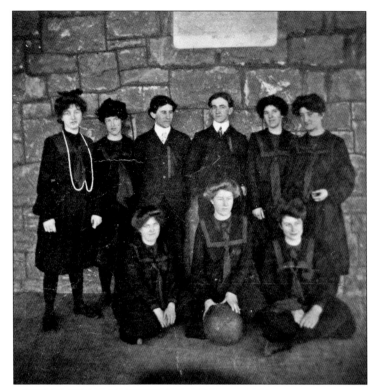

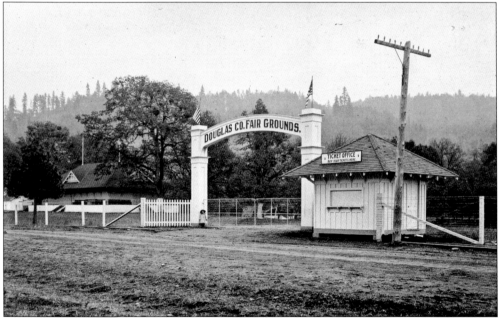

The first racetrack was established on June 4, 1870, a mile east of Roseburg. The track was one-half mile long. Residents decided this would be a good location for a county fair. This photograph shows the entrance gate used by fair attendees in August 1895. It was on the east side of Douglas Street beyond Deer Creek Bridge. Besides the harness races, the primary attractions were the agricultural exhibits and livestock contests.

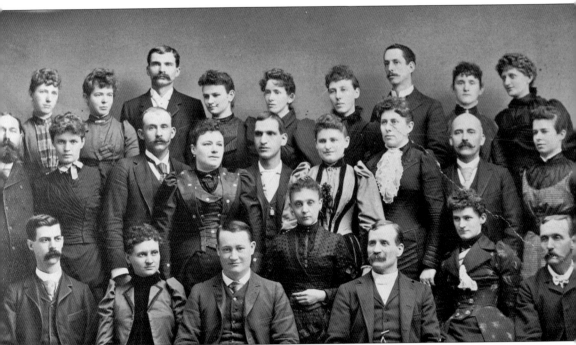

Whist was a type of bridge popular in the nineteenth century. The Roseburg Whist Club poses here on March 6, 1892. They are, from left to right: (first row) Fred Zigler, Mrs. Wendell T. Wright, Walter S. Hamilton, Lillian Moore, Wendell T. Wright, Elizabeth Parrott, and Free Johnson; (second row) Louis A. Sanctuary, Effie Willis, Elmer McBroom, Mrs. Thomas R. Sheridan, Herman Marks, Maggie Abraham, Zelia Zigler, George W. Kimball, and Etta Willis Evans; (third row) Marietta Howell Kohlhagen, Lulu Willis, Eugene Parrott, Lena Willis, Winnifred Mosher, Francis Jane Howell, Fred S. Floed, Emma Mosher, and Hattie Wright Campbell.

This is Leland A. Thompson, dressed as the fire company's mascot. Boys as old as five years old wore long curls. Leland and his twin brother Louis were born in 1894 to Anthony and M. Carrie Thompson. Louis died at the age of seven months, and Leland died of tuberculosis at age 20. Their father was a member of the 1889–1890 Umpqua Hose Company and owned the Imperial Saloon.

Pageants were popular all over Oregon in the early 1900s. In 1906, Harry and Harold Ballf, pictured here, won first prize at the Portland fair as the best looking twins. Their curls and ribbons would have won any prize. They were the sons of Peter and Bridget Ballf, who raised a large Catholic family.

This lovely young lady, Daisy Frater Abraham, wears an Oregon crown. The People's Store, owned by the Abraham family in 1903, sold material, ready-made clothing, shoes and jackets. A walking skirt sold for $1.50 and a man's suit started at $7.50. The Abraham family supported and participated in many of the city's events.

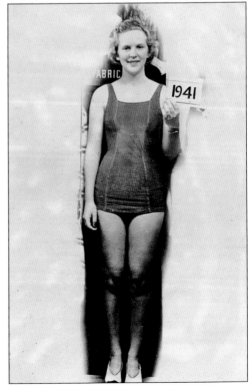

Beauty contests and fashion shows were popular pastimes. In 1941, Ella Mae Cloake Young modeled this bathing suit from Harth's Toggery, owned by Henry Harth. Harth's was the main clothing store in Roseburg for almost 50 years. Their slogan was, "If it's correct, Harth's have it and if Harth's have it, it's correct."

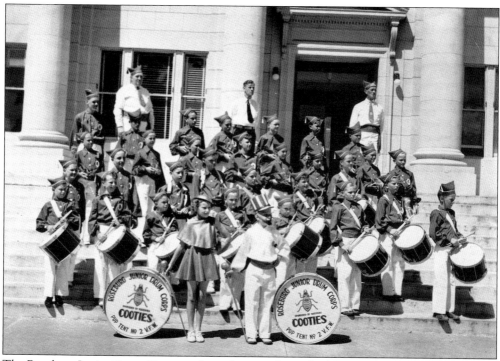

The Roseburg Junior Drum Corps performed in parades and other events. They were designated Pup Tent No. 2 and sponsored by the Veterans of Foreign Wars. The "Cooties" are pictured standing in front of the county courthouse about 1940. The three men in the back are Van Vorst (left), J.D. "Snap" Gilmore (center), and Ward Cummings.

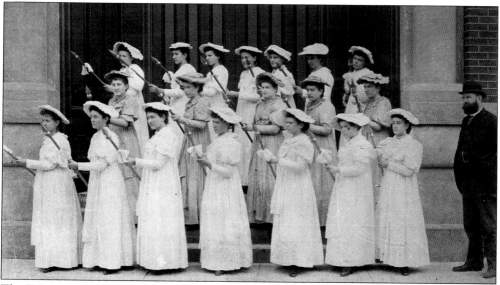

The Empire Drill Team was organized in 1887 to provide an activity for young women. J. R. N. Bell and Thomas Gibson were the directors. Only 17 members of the group are identified: Ella Boyd, Maybelle Elliot, Clara Fields, Effie Fisher, Maye Fisher, Echo Gaddis, Minnie Glendenning, Effie Jones, Queenie Kidder, Jennie Limbocker, Mattie Perry, Regina Rast, Bertie Richardson, Helen Smith, Addie Stewart, Mabel VanBuren, and Miss Wright.

On August 24, 1893, a new Douglas County Concert Band was organized with Prof. Frederick H. Applehoff as the new bandleader. He is pictured here in his elegant band uniform. He died in 1932.

The Douglas County Concert Band was very popular. Here they are marching in a parade (1920–1923) between Jackson and Cass Streets. Some of the members were A. T. Lawrence (drum major), Charles Clevenger (piccolo), George Langenberg (solo coronet), William R. Benjamin (first coronet), Louis A. Belfils (second coronet), Fred M. Zigler (solo alto), Claude Cannon (first alto), Albert Bitzer (first trombone), and Joseph Sykes (bass drum).

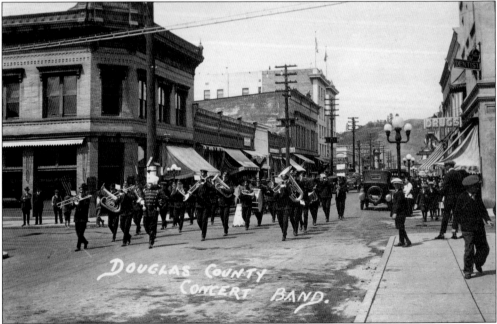

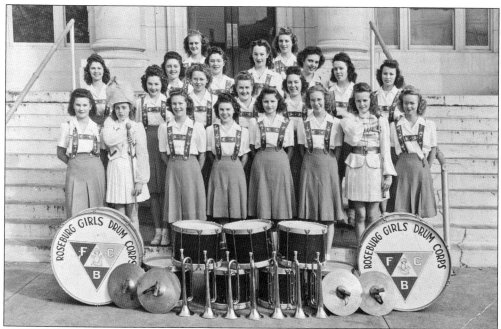

The First Knights of Pythias Drum and Bugle Corps posed in front of the courthouse in 1942. From left to right are (first row) Shirley Woods, Shirley Carter, Ev Bird, Jean Ashworth, Alice Harvie, Eula Carnahan, Phyllis Hinsdale, and Audrie Roselund; (second row) Gerry Stephens, Ann Carter, Virginia Roselund, Barbradel Froem, Betty Wilson, Lila Jean Talbert, and Marylin Preston; (third row) Evalee Grizzle, Betty Lou Crocker, Avis Hampton, and Bev Nichols; (fourth row) Jean Turner and Shirley Shrum.

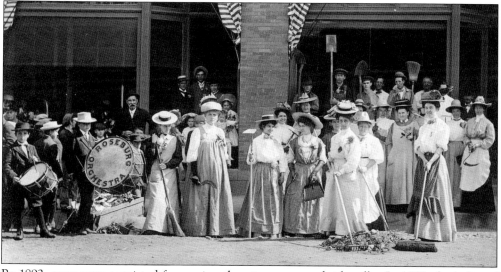

By 1892, cows were restricted from using the city streets and sidewalks. In 1909, the ladies of Roseburg sponsored a street cleanup and were accompanied by the town orchestra. Clara Park is to the right of the drum, holding a broom. Moses Rice is second from the right in the back row, holding a broom, wearing a hat, and smoking a cigar. His wife, Jessie Buell Rice, stands with a floral hat in the second row in front of the brick column. The streets were paved shortly after this photograph was taken.

This was the art and embroidery club about 1900. Of the 13 women and eight children shown in the photograph, only nine names were listed: Annie Bradford, May Patrick, Mrs. Roadman, Clayte Black Osharan, Hattie Lee Stephenson, Blanche Rhoades, Bell Stephenson, Clara Patrick, and Mary Lewis.

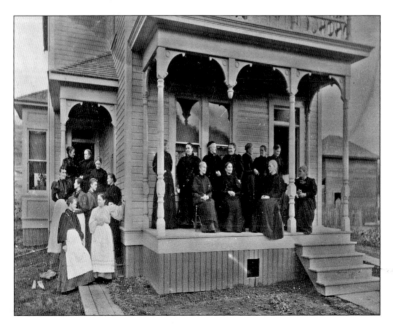

This is a photograph of the 1896 knitting club, which met at the home of Mary Kruse Shupe. The ladies shared patterns and helped each other with difficult stitches. Knitting was a skill necessary to provide stockings, sweaters, hats, and gloves for the entire family.

Garden parties and teas were popular activities, particularly among well-to-do ladies. This birthday party (held between 1894 and 1897) for Caroline Zigler included Emily Autenreith, Delia Aiken, Mary Barker, Clarrisa Berry, Julia Bradley, Katharine Elliot, Sarah Estes, Marie Flint, Josephine Gosser, Louisa Graves, Sarah Hamilton, Mrs. George Happersett, Mrs. Frank Howell, Mrs. Howard, Lillian Jackson, Clara Oehme, Mrs. Seldom, Snow Willis, and Zelia Zigler.

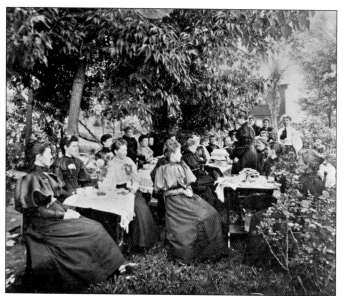

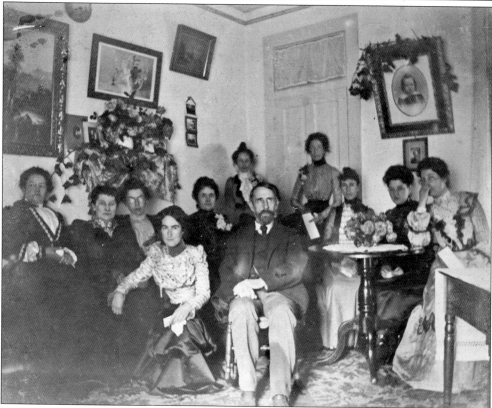

In 1895 Sarah B. Child founded the Mental Culture Club. It eventually became the Roseburg Women's Club in 1923. Their stated purpose was to provide intellectual and social stimulation to members. Names listed on their charter include the following: Sarah B. Child, Edith Churchill, Mary Fisher, Belle Godfrey, Hattie Godfrey, Mayette Kohlhagen, Annie Rice, Helen Smick, and Helena Wollenberg. Oscar Godfrey is included in this picture, as the meeting took place in his home.

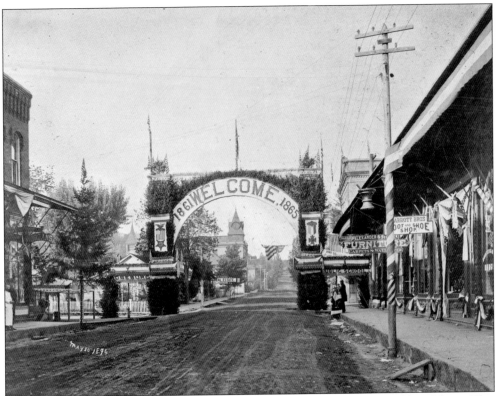

On May 10, 1894, the city celebrated the dedication of the Oregon State Soldiers Home. This arch graced Jackson Street looking south down Oak Street, and provided a viewing stand for the public school students. Also in view were D.S.K. Buick Real Estate, Alexander and Strong furniture store (owned by Byron W. Strong), Parrott Brothers Shoe Shop, a drug store, and the Odd Fellows Hall.

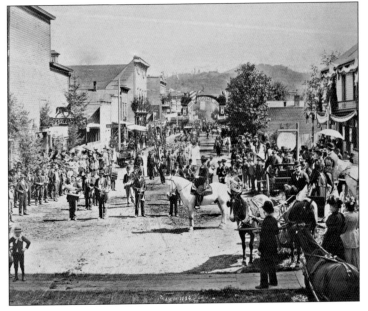

This parade photograph was taken on May 10, 1894, on the corner of Cass and Jackson Streets. The Grand Army of the Republic (GAR) sponsored the celebration dedicating the Oregon State Soldier's Home. It is estimated that 7,500 people were in the crowd. The 1900 census lists the population of the county as 14,500, and the city of Roseburg as 1,789.

This was the Roseburg CFC secret
society of 1898. The members
pictured are, from left to right:
(first row) Bessie Wharton and Bess
Coshow; (second row) Elizabeth
Kidder, Emma Selbrede, and Vivian
and Hazel Jewett; (third row) Elsie
Benedick, Ella Black, and Lillian
and Della Moore. The boys' club
was called KILL. Secret societies
were popular in the late 1800s and
early 1900s, and often involved
elaborate rituals and initiations.

Pictured here is the court for
a street fair held September
17–19, 1900. Helen Willis (in
the foreground) was queen, and
her attendants were, from left to
right, Sylvia Stearns, Ellena Reed,
Addie Sacry, and Eva Jacobs.

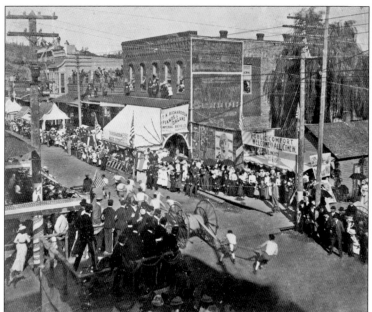

In 1901, the fire department demonstrated their hose cart team's prowess in a downtown parade. This photograph was probably taken at the Fourth of July celebration. People were hanging out of windows, sitting on roofs, and standing on sidewalks. The street was covered with temporary wooden planks to keep down the dust.

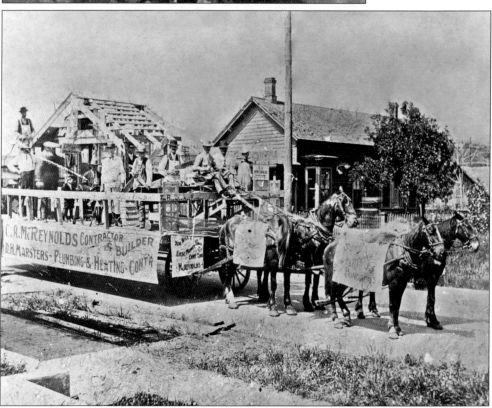

This horse-drawn float advertised the construction businesses of C. A. McReynolds, a building contractor; and D. H. Marsters, a plumbing and heating contractor. McReynolds was known as the "Bungalow Man," as he specialized in bungalow homes popular between 1910 and 1925. There was a short building boom during that time as the city expanded and new homes were needed.

The first Strawberry Carnival was held May 13–15, 1909 and was sponsored by the Roseburg Commercial Club. For the next 10 years, it was the major event in southern Oregon. Booths were erected on Jackson Street to sell food and products to the crowd. In the background was a thatched stage with steps leading up to it.

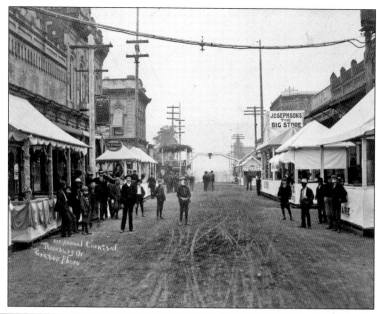

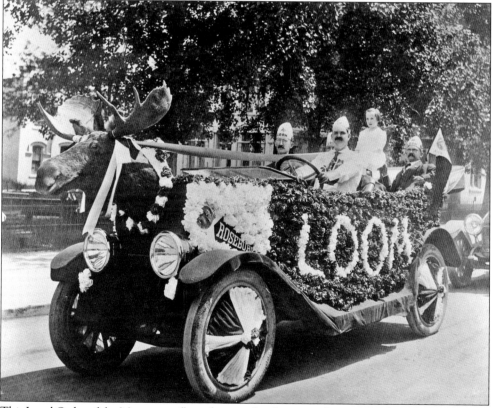

This Loyal Order of the Moose auto float, decorated with a magnificent moose head, was part of the 1909 Strawberry Carnival parade. This photograph, taken on Douglas Street in front of the Douglas County Courthouse and jail, shows from left to right: Perry Foster, an unidentified man, driver Sam Crouch, Evelyn Quine Coen, and George Brown (Douglas County district attorney 1904–1913).

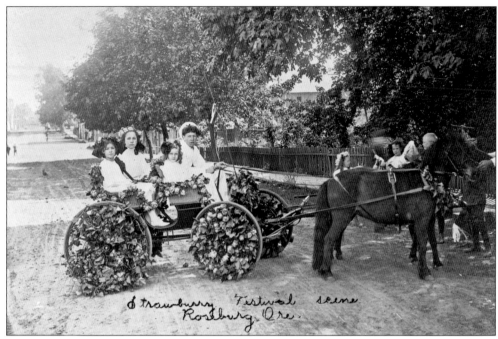

This little pony cart was an entrant in Friday's 1909 Strawberry Festival parade. The three little girls were immaculate in their white dresses, shoes, and socks, with elaborate flowered wreaths and ribbons in their hair. Capitola Willis was voted the carnival queen with 9,193 votes. Maybelle Miller, Lenore Dale Coshow, and Edna Jones were her attendants.

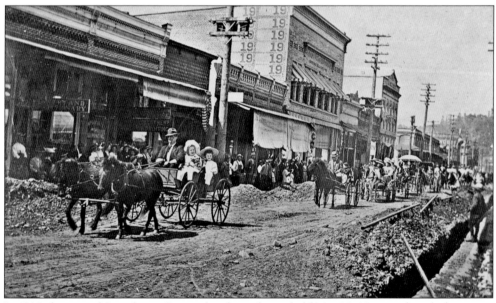

In 1910, the second Strawberry Carnival and parade was held May 11–13, even though the streets were torn up to install water and sewer pipes in preparation for more paving downtown. Handsome buggies and matched horse teams were shown off to residents lining the streets.

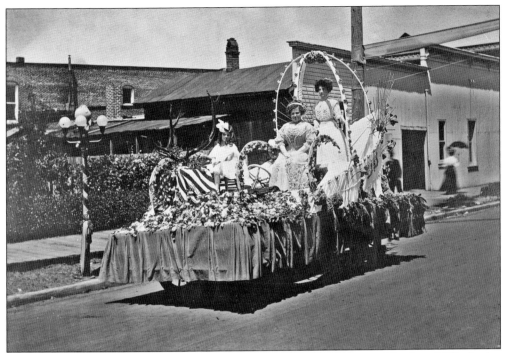

The 1910 celebration featured the Elks Parade on Thursday morning. The Local Elks Lodge entered this extravagantly decorated motor float in the afternoon automobile parade. It was driven by Dr. George E. Houck, with Mrs. Vel Broadway and Gertrude Rast as two of the riders. Dr. A. S. Seely won first place with his automobile decorated as a battleship. The rose and strawberry exhibits offered cash prizes to entrants.

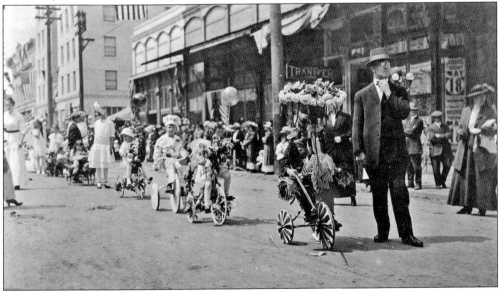

Children in all manner of costumes decorated their tricycles with flowers, ribbons, and papier-mâché. On Friday in 1910, 750 school children marched in their own parade followed by a band concert, a maypole dance, a strawberry exhibit, and a livestock parade. Saturday evening featured an open-air street masked carnival.

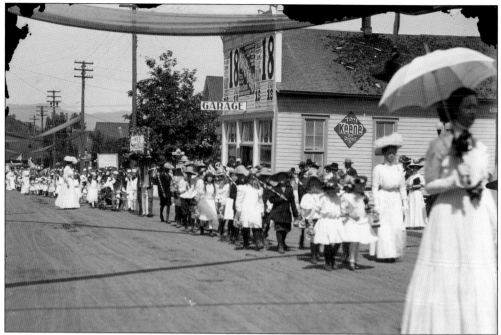

In 1910 children were let out of school for three days to allow them to participate in the carnivals. The Children's Parade started on Cass Street at 10:30 a.m. Friday. It featured children marching in groups accompanied by teachers carrying large hats or parasols. Prizes were given for the school with the largest percentage of students participating in the parade.

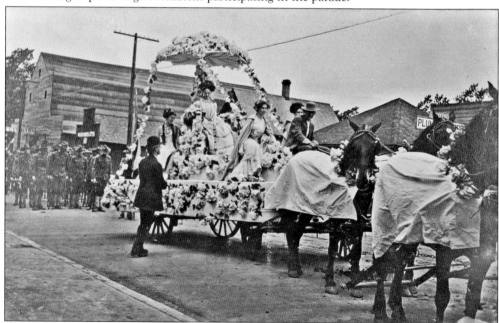

This horse-drawn float of 1911 featured the festival queen Ethelyn Vaughn, daughter of Mary Doss, and her attendants. Vaughn received 47,180 countywide votes. Dorothea Abraham, daughter of Sen. and Mrs. Albert Abraham, was the junior queen. A special feature of the carnival was a daring exhibition of airplane gymnastics on May 11 and 12.

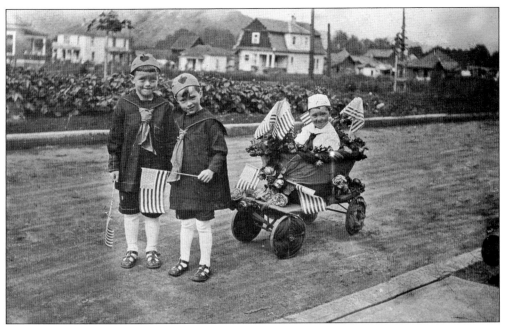

Children were popular entrants in the Strawberry Carnival parades. This photograph shows Henry Weber and Stewart Stephens pulling a wagon decorated in patriotic flags in the 1911 parade. Carl Stephens was seated. The Baby Parade took place on Friday at 10:00 a.m. Two prizes were awarded for best decorated carriage carrying a baby three years or younger.

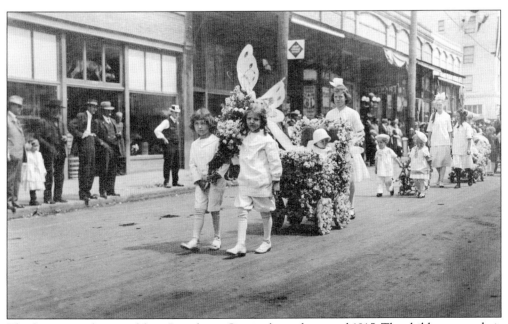

This buggy was decorated for a Strawberry Carnival parade around 1915. The children wore their best white clothing and many girls had big bows in their hair.

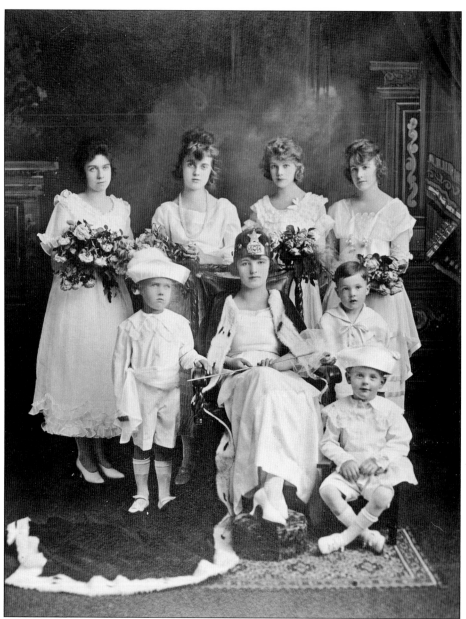

This was the ninth annual Strawberry Carnival and Sportsmen's Tournament court in May 1919. The princesses pictured are, from left to right, (standing) Dorothy Veatch, Maybelle Miller Young, Edna McLaughlin, and Mae Burr. The three boys are unknown. Queen Maxine McLaughlin Revel, daughter of R.L. McLaughlin, was seated. Queen Maxine won with a total of 17,935 votes. The school children's parade opened the festivities with Sheriff George E. Quine, as marshal of the day, leading the parade. Gertrude Laird was named junior queen and rode in an elaborately decorated float drawn by four Shetland ponies. Pauline Clark was her attendant. This was the first year motorcycle races were held. Besides speed races, there was a sidecar race and a blindfolded spark plug contest. Rose School won first prize in the school parade. The students carried flower-covered parasols and huge strawberries. The thousands who attended this three-day event exceeded attendance at all previous carnivals.

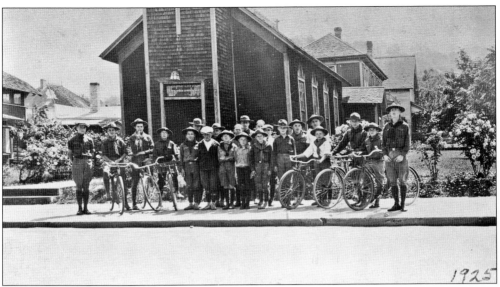

Scouting was a popular activity for boys. This 1925 photograph taken in front of the old Episcopal Church shows a Boy Scout patrol ready to join the parade. Six planned to ride their bicycles.

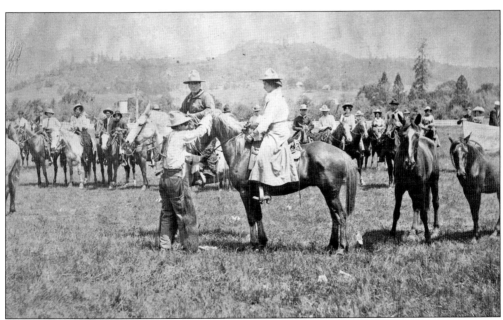

The first rodeo was sponsored by the local chamber of commerce. It took place in 1925 and lasted an entire week. Records indicate the chamber demanded at least 500 Native Americans participate in horse racing, bronco busting, roping, war dances, and ball games to create enough interest in the rodeos. The participants kept the money earned minus the cost of expenses. The rodeo rider in the above photograph is Mamie Furlong Denny Archambeau.

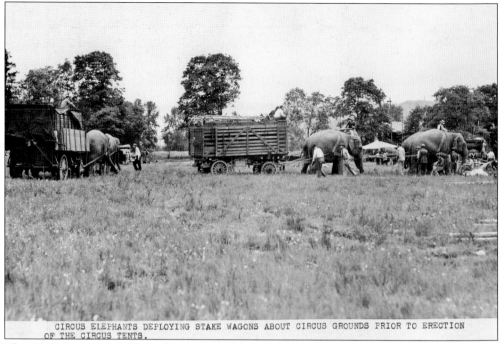

CIRCUS ELEPHANTS DEPLOYING STAKE WAGONS ABOUT CIRCUS GROUNDS PRIOR TO ERECTION OF THE CIRCUS TENTS.

The Al G. Barnes-Sells Floto Circus arrived by train and paraded through town on its way to Bellows Field near where Douglas Community Hospital was later located. Buffalo Bill's Wild West Show also traveled with the Sells Floto Show. In 1914, a poster advertised 600 performing animals and 65 sensational animal acts, including 24 full-grown African lions. These elephants are moving stake wagons for the erection of circus tents in May 1938.

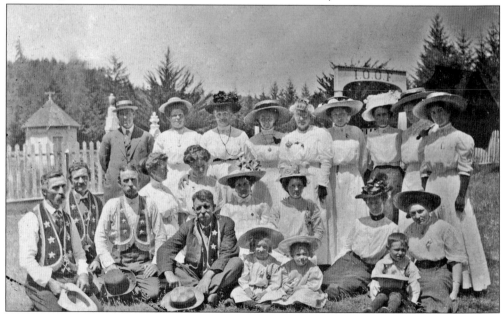

This group was resting in the Odd Fellows (IOOF) Cemetery about 1910, probably after doing a cemetery cleanup. The men are wearing IOOF vests (called stoles), so it must have been an official function of some kind. The Odd Fellows built many cemeteries around Oregon.

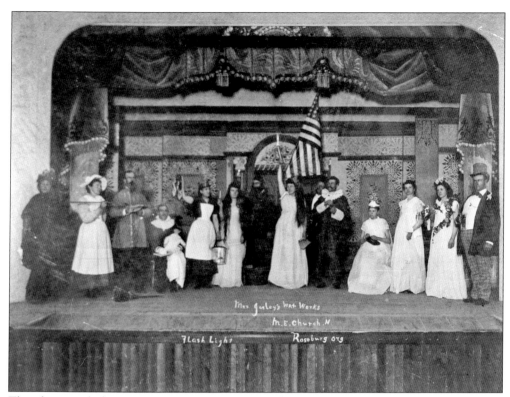

This photograph shows the cast of *Mrs. Jarley's Wax Works* performed in the Opera House by the Methodist Church sometime between 1894 and 1897. There were 14 actors. Clarrisa Berry played the lead. The Umpqua Hose Company No. 1 sponsored the play *Nevada* on March 8, 1889. It netted the fire department $40. The fire department also sponsored masquerade balls, as well as Thanksgiving, Christmas, and Fourth of July dances.

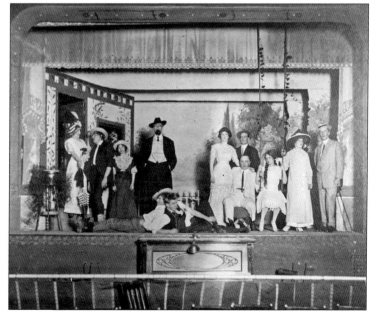

Plays were popular attractions. Here the cast of *Mary Jane's Pa* poses in the Marks building. Standing from left to right are Gertrude Rast, Clark Barar, an unidentified woman, James Zurcher, Lois Shoemaker, Wallace Alexander, Constance Moore, and Mr. Gardner. Seated in the swing are Dr. Vincil (left) and Hildegard Shoemaker. The two men lying on the floor are unidentified.

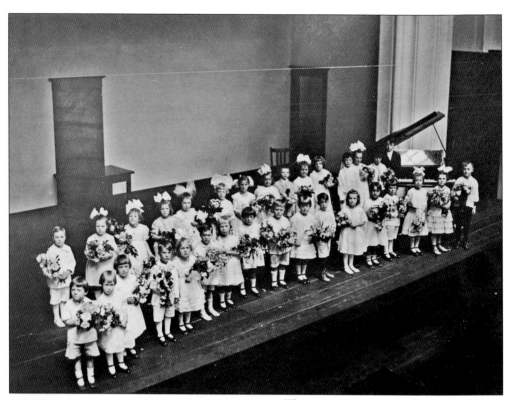

This interior view of the Opera House sometime between 1894 and 1897 shows the stage with 32 children holding bouquets, and a grand piano in the background. In 1898, Manager Strong had to request that all ladies remove their elaborate hats so the audience could see the stage.

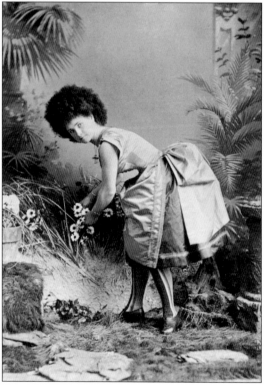

Dot Claire was a 17-year-old actress and/or circus girl, popular in the 1880s or 1890s. Her striped stockings and short skirts were terribly immodest for the times, when sleeveless bodices were rarely seen. Yet she was wearing a cross necklace, and had a bustle on her dress. She traveled back east to seek her fame and fortune.

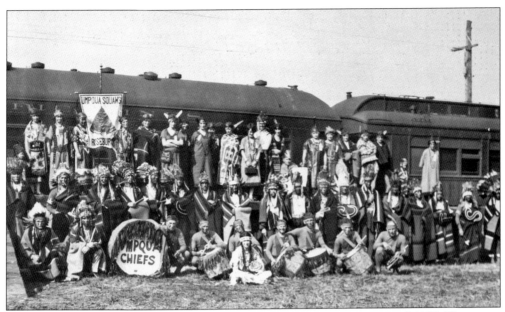

The Umpqua Chiefs and Squaws was a city booster club between 1920 and 1925. They wore beautiful woolen Native American blankets manufactured by the Pendleton Woolen Mills. The club participated in various parades, celebrations, and contests. The men wore fancy feathered headdresses. George Neuner was the Big Chief and was United States District Attorney for Oregon from 1925 to 1933. The Umpqua Squaws became the Roseburg Chapter of the Business and Professional Women in 1926.

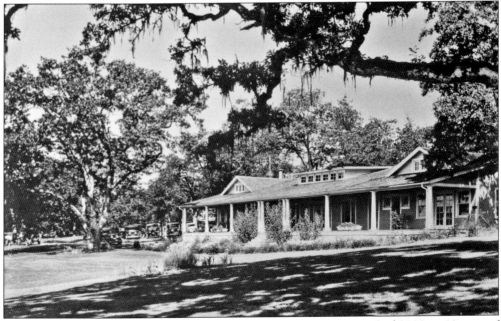

This was the original Roseburg Country Club clubhouse, built in 1923 for $5,300 on 93 acres of land outside the city limits. The clubhouse was replaced in 1960, and renovations continued on the golf course. Over the years, the membership has sponsored a variety of improvements and additions to the existing facilities.

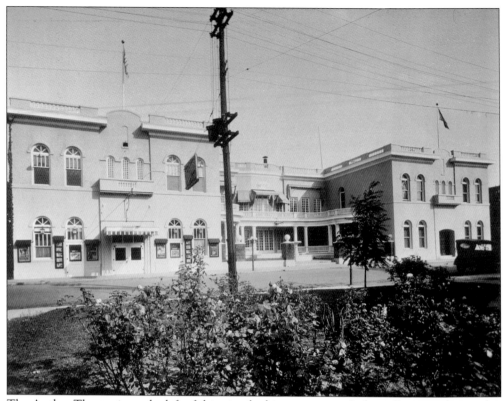

The Antlers Theater is on the left of this view looking east across Jackson Street, with a garden in the foreground. The fountain in the front was filled with goldfish, which were a constant attraction for the city's children. Other theaters included the Liberty and the Majestic. In 1914, it cost 25¢ for adults and 15¢ for children to see the movie *The Barrier*, an Alaskan frontier drama in four parts.

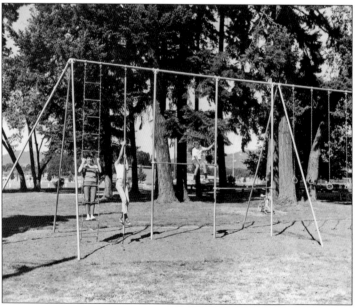

Among the 27 parks in Roseburg, Stewart Park, the largest, is 230.46 acres. Originally the land was owned by the Veterans Administration and donated to the city in 1957. The picture above, taken in 1960, shows children playing on equipment at the park. It was named after Dr. Earle B. Stewart, a supporter of children's athletics. (Courtesy of the Roseburg City Parks Department.)

Four

WHEELS GO AROUND
HOW WE GET WHERE WE WANT TO GO

Wheels are the foundation of our world and help society move forward into the future. They provide transportation for goods and people in every manner possible. From early horse-powered wagons, paddle wheeled riverboats, and trains, wheels have helped Roseburg change and grow. Wheels on toys, children's scooters, and adult motorcycles gave us the means to enjoy our lives in ways we'd never before imagined. Motorcars, trucks, threshing machines, and airplanes have changed the city in innumerable ways. Whether good or bad, these inventions and others like them will surely continue to change the face of our town and the lives we live.

Aaron Rose recognized that Roseburg was a natural location for a city situated between the Willamette and Rogue River valleys. The original Scott-Applegate Trail ran directly through downtown and provided access for fur traders, immigrants, and miners. The railroad arrived in 1872 from Portland, but the southern mountains provided a barrier only breached in 1882. Residents invested heavily in building roads and bridges, knowing they needed both to survive and grow. Today Interstate 5 curls around Mount Nebo, parallel to the river, and bisects the city, providing easy access north or south. Scenic highways lead west to the ocean and east to Crater Lake, showcasing the natural wonder of the surrounding mountains.

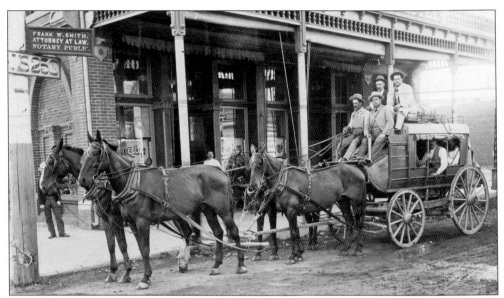

The first stage arrived in July 1860, and was operated by the California and Oregon Stage Company. Teams of six horses were changed about every 12 miles. Drivers, such as Thomas B. Burnett, drove about 45 miles before being relieved. Many times during the winter it took 10 hours to drive from Roseburg to Canyonville. Passengers often had to walk or help push the coach through deep mud.

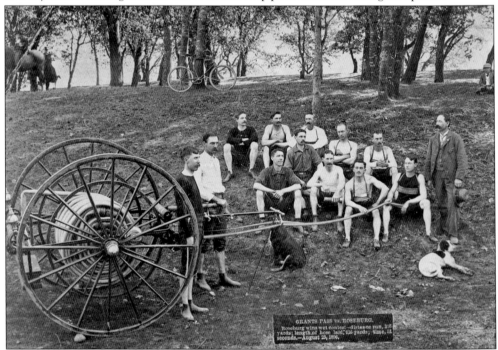

On August 26, 1896, the Roseburg fire department hose team (shown here wearing their new racing shorts) won a contest against Grants Pass. Eighteen men were listed on the official 1896 roster: Alva A. Bellows, Frank W. Benson, F. W. Carroll, William H. Carroll (foreman), E. A. DaMotta, Ged Day, E. Everton, John G. Flook, H. B. Groves, Roy McClallen, J. A. Newman, J. A. Norman, Charles W. Parrott, F. F. (Pat) Patterson, Dexter Rice, Samuel Sykes, R. E. Veatch, and Charles Wharton.

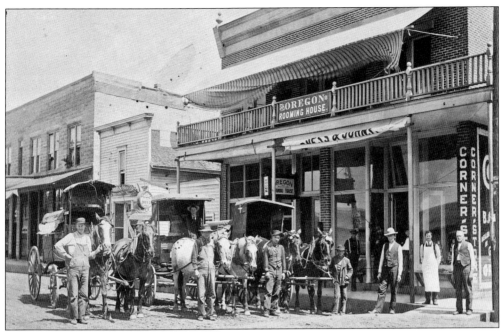

These horse-drawn delivery rigs were parked in front of the Oregon Rooming House on the northeast corner of Sheridan and Lane Streets. The Minnesota Rooming House was next door. Dray teams served as the delivery vehicles for business owners. On January 5, 1903, the city council approved a reward of $2.50 to the first teamster who appeared at the firehouse to help haul the hose cart to fires when the alarm bell rang. It applied only between October 15 and April 15, when the black mud in the streets prevented the firemen from pulling the hose cart.

Usually horses or mules pulled buckboards. In this case, J. G. Truman has hitched up two burros to pull his wagon. The original Methodist Church is pictured to the right in the background near the corner of Main and Lane Streets. Built in 1857 with only one room, it could hold about 50 people. A rope near the entrance rang the bell in the tower.

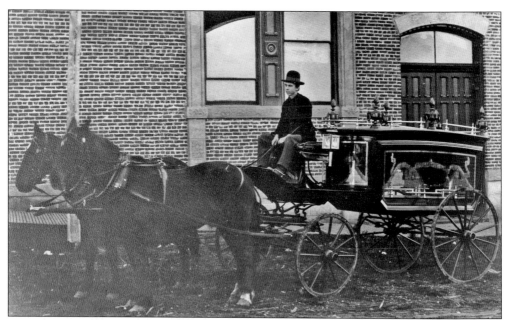

On October 17, 1868, Earl Benedick drove this horse-drawn hearse recently arrived from San Francisco. From that time forward, its gold-tinted elegance graced many funerals. It was free to all who believed in showing respect to deceased friends. The women of Roseburg raised money to pay for it in May 1867 with a Ladies Fair. This photograph was taken about 1895.

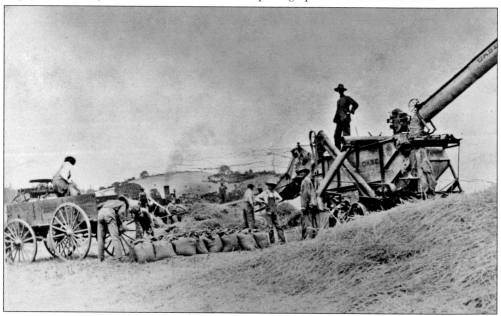

In September 1878, Thomas Winniford threshed 18,000 bushels of grain in 22.5 days. Some 200,000 bushels were in Roseburg warehouses, and wheat was worth 70¢ a bushel. John G. Flook built the New Era Flourmill in 1880 that had three stands of rollers and a capacity of 50 barrels a day. The water race and dam cost $20,000. The mill itself cost $10,000. In 1886, Aaron Rose became his partner. These men were threshing grain with a steam traction engine and case separator. Grain was placed in tied sacks and hauled off by team and wagon.

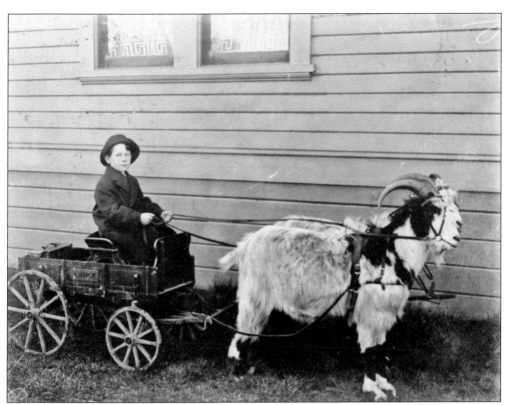

Cliff Williams rides in his child-sized buckboard pulled by two billy goats. When horses were too big for the job and ponies weren't available, goats would just have to do. He was not only having fun but also learning a valuable skill.

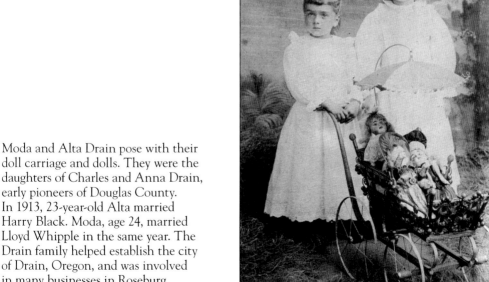

Moda and Alta Drain pose with their doll carriage and dolls. They were the daughters of Charles and Anna Drain, early pioneers of Douglas County. In 1913, 23-year-old Alta married Harry Black. Moda, age 24, married Lloyd Whipple in the same year. The Drain family helped establish the city of Drain, Oregon, and was involved in many businesses in Roseburg.

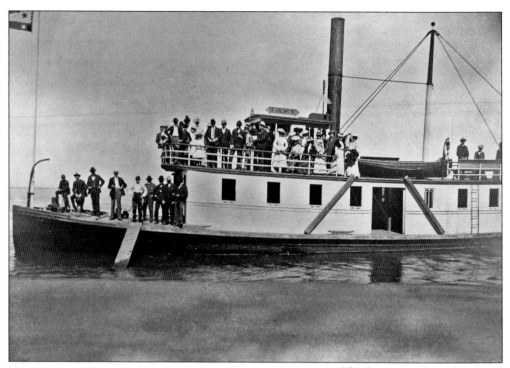

The *Swan* was the only steamboat to navigate the Umpqua all the way to town. It arrived on August 6, 1870. Other steamboats hauled passengers and merchandise from the coast to Scottsburg. The *Eva*, pictured here in 1902, was used as a freight and excursion boat on the river until 1916 when the train arrived in Reedsport.

Cliff Benson, son of Frank and Hattie Benson, rides his metal tricycle sometime between 1895 and 1900. Frank Benson taught school in Roseburg and later became governor of Oregon in 1909.

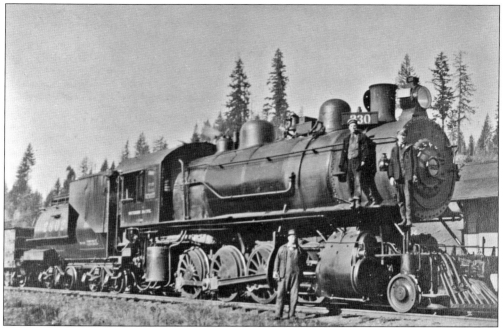

This is Southern Pacific Engine No. 2802 with engineer Stephen Willis Jr. Aaron Rose dedicated 10 acres of land for the railroad right-of-way and a depot site in 1872. This established Roseburg as the major transportation center for Southern Oregon. In 1887, the railroad was finally completed to California and Roseburg was no longer the terminus.

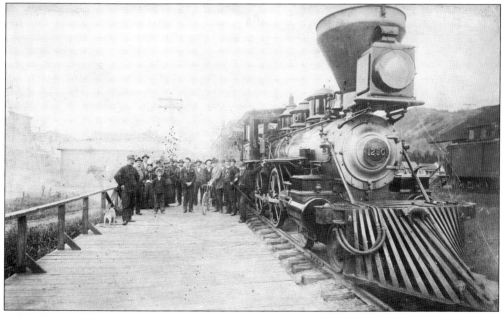

In his diary, William Allen described the arrival of the first engine on October 26, 1872: "The train rolled in and came to a stand at the foot of Washington Street. A large crowd flocked around it and went right up to the engine. Suddenly the steam safety-valve on the engine popped off with a roar, and people who were close to the engine fell all over each other getting away, as they thought the engine had blown up."

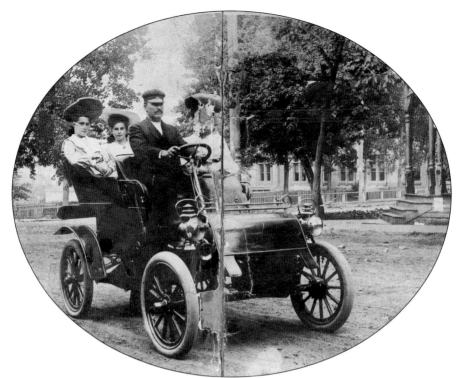

On June 2, 1904, John Sutherlin purchased the town's first automobile. He ordered a Ford Tonneau touring car from Samuel K. Sykes for $1,600. Shortly after it arrived, he and William Hurd frightened Claude Cannon's horse, which pulled its buggy off the road into a ditch, injuring Cannon's arm. A month later Sutherlin met Martin W. Bowker's buggy on the Deer Creek covered bridge, scaring the horses and wrecking the buggy.

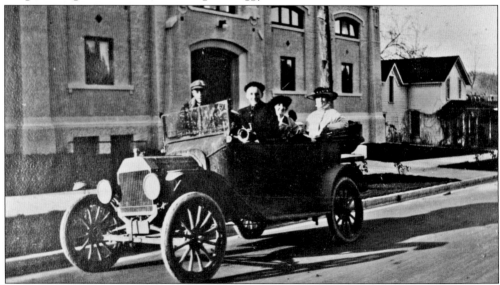

Around 1914, Sam Smith, owner of a local livery stable, established the first jitney car service to haul passengers, charging 5¢ each. Archie Ferguson was the driver of the "Jitney 31," which advertised the office phone number. For 25¢ he would drive passengers as far as the Edenbower neighborhood.

In 1908, Henry and Eva Harth, owners of Harth's Toggery, drove their 1907 model Tourist automobile over the old Coos Bay Wagon Road to the coast. Al Dailey, a blacksmith employed in the Pilkington Brothers machine shop, accompanied them. It was the first motorcar to travel on the rugged road and took about one week.

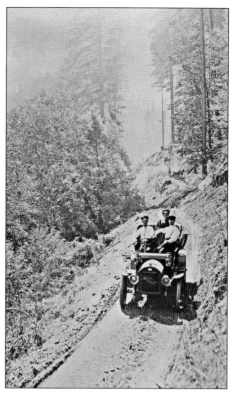

On May 18, 1905, the state passed a new automobile law affecting the owners of all motor vehicles. For a fee of $3, each owner was required to register his or her name, address, and description of vehicle. Vehicles were required to have a light, a muffler, and efficient brakes. A speed limit of 8 miles per hour was established for downtown areas. Claude Cannon, Roseburg's first auto salesman, drove this early model, right-hand drive Reo auto.

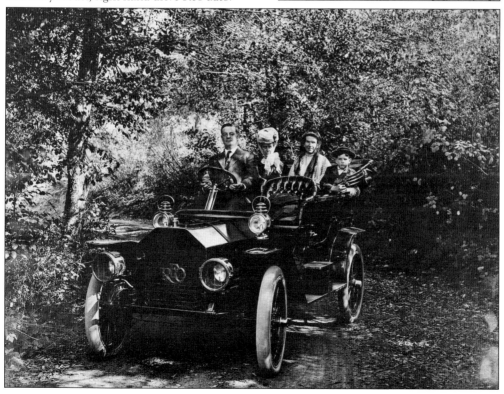

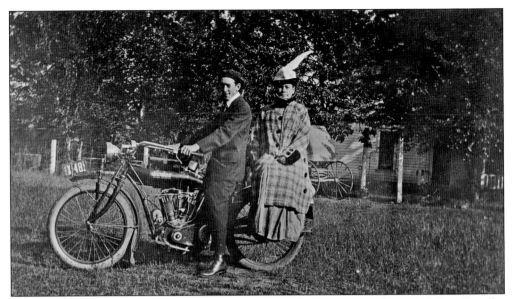

William C. Conner, the editor of the *Plaindealer*, owned the first motorcycle in 1905. Fritz Stauffer, manager of the Roseburg Brewery and Ice Company, bought the second, a Rambler motorcycle, from William Hodson and Company. This photograph shows Lawrence and Emma Krogel riding an early Indian motorcycle.

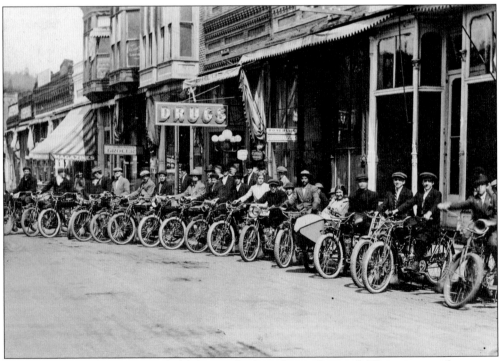

In 1919, motorcycle races were held during the Strawberry Carnival. There was a sidecar race and three elimination speed races. Just for fun, entrants in the spark plug race were blindfolded before trying to replace their plug in the shortest time possible.

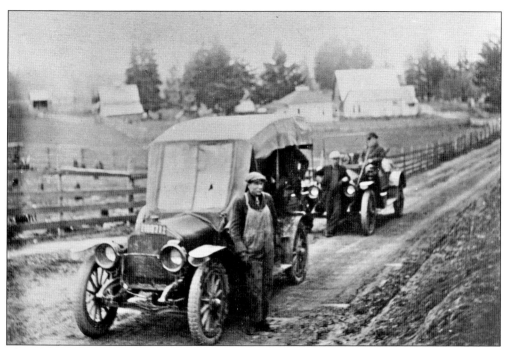

This photograph shows Barney Walker and two auto stages, owned by George Kohlhagen, parked on Highway 42 in 1918. Once roads improved and autos took over the business of hauling passengers between Roseburg and smaller rural towns, horse-drawn stages became a thing of the past.

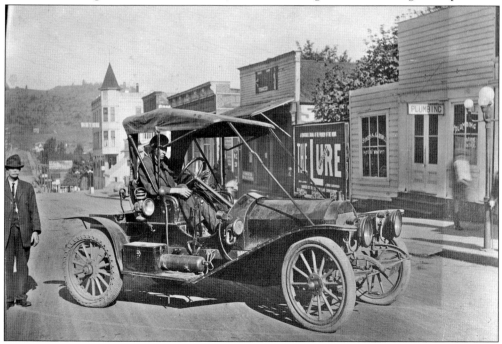

This two-seater right-hand automobile was parked on Jackson Street about 1915. Without a cover on the car, the driver needed to wear a broad-brimmed hat and a heavy overcoat to keep off the dust and rain. This view looks north, showing the Sykes and Carroll Plumbing store on the right.

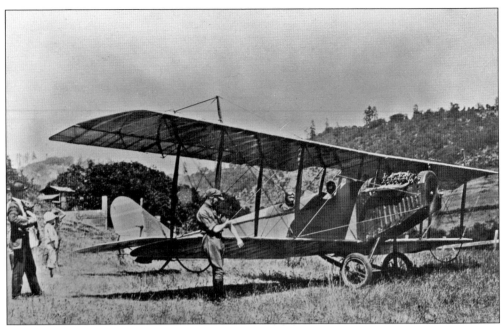

The first barnstorming plane, a Curtis Jenny, visited Roseburg after World War I. The pilot sat in the rear cockpit and the passenger sat in the front. It cost $3 for a flight over town. This photograph was taken at the National Guard rifle range east of town.

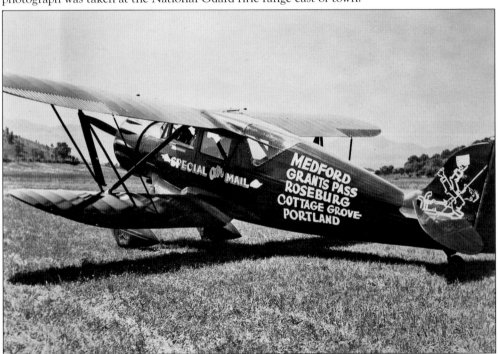

This plane carried the first airmail letters on May 19, 1938. The biplane had "Special Air Mail" and "Medford, Grants Pass, Roseburg, Cottage Grove, Portland" painted on one side, and a caricature of a man holding a letter on the other. T. A. Culbertson was the pilot and A.H. Barnwell was the passenger. They left at 11:30 a.m. headed north and carrying 1,200 pieces of mail.

Betty Kruse and her registered Boston terrier were a common sight in the 1930s. Here she is pictured with "Lady Pat K" as they ride together on their scooters. Lady is the one with the pipe.

Little girls love to play with dolls and toy baby buggies. Doreen Lewis, daughter of H. O. and Della Lewis, is pictured here at about four years old, all dressed up and ready to go shopping with her babies.

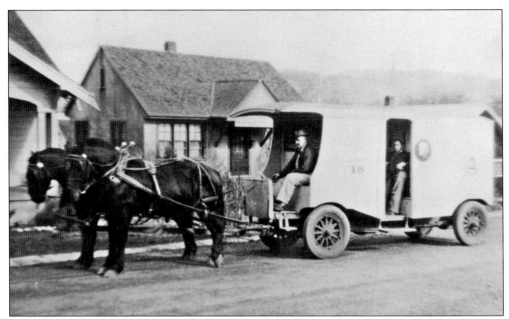

During World War II gasoline was so strictly rationed that businesses such as the Umpqua Dairy resorted to using horses to pull their delivery wagons. This delivery van was dubbed the "War Wagon." Umpqua Dairy provided milk, ice cream, eggs, and butter to customers. Ice cream was sold in small square dishes to passengers on the trains. Today Umpqua Dairy is one of the leading dairies in the Pacific Northwest. (Courtesy of the Umpqua Dairy.)

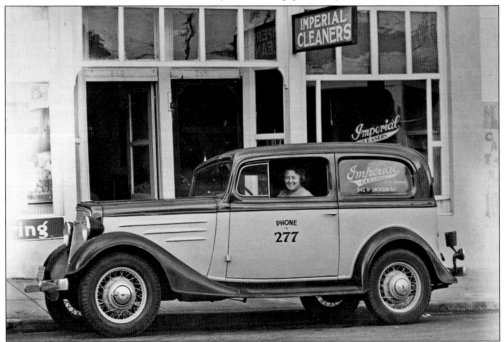

Stella Spencer drives an Imperial Cleaners delivery van in the 1940s. The store was located at 342 North Jackson Street. Imperial was a popular establishment, and Stella was well known around town. Many businesses provided delivery service for their customers.

Five

DISASTERS
FIRES, FLOODS, AND EXPLOSIONS

Disasters can happen anywhere at any time. Roseburg's location between two major rivers has always left it open to flooding. Two "century" floods have devastated the city—one in 1861 and one in 1964. Winter floods and slides frequently threaten roads and bridges along the river. The county and state highway departments work hard to keep the roads open. Occasionally homes and businesses are inundated with mud and water. Each time, people pick up what's left and start over. Luck and a vigilant volunteer fire department kept major downtown fires to a minimum. A well-maintained and professional fire department serves the city today.

The first major fire of significance occurred on August 19, 1884, when the biggest hotel in town and several surrounding blocks burned to the ground. It caused $111,120 in damage.

The Blast on August 7, 1959 will always be a significant event in Roseburg's past. It was also the third most devastating disaster in Oregon history, killing 14 people and injuring at least 125. While it destroyed eight downtown city blocks and caused nearly $12 million in damages, it also provided a catalyst for changing the laws covering interstate transportation of explosives. Most of the damage was covered by private insurance and no national disaster relief was awarded. The residents of Roseburg rebuilt their lives and their town while maintaining their generosity and equanimity. Today little remains of that devastation except memories.

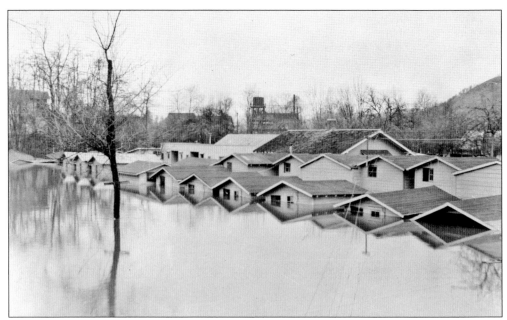

The worst flood of the nineteenth century took place on December 8, 1861. Captain Hall wrote in his diary: "The flood was so great it maintained its body for miles as it swept out to sea. In its current were barns, sheds, log cabins, chicken coops and even haystacks. The water was filled with the bodies of cattle, horses, sheep and pigs from ranches." This photograph from 1920 shows houses underwater at the Deer Creek and Oak Street Bridge.

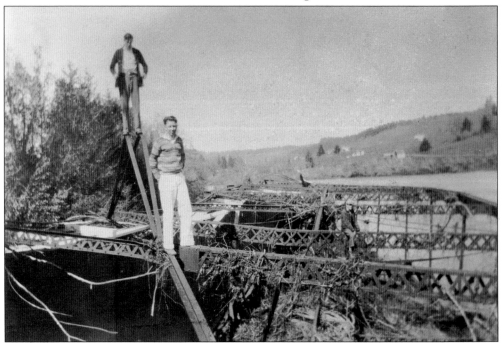

This photograph shows Marshal Lyons (above) and Henry Beckley at the ruins of the Mary Beckley Bridge after a flood in March 1927. It was taken at Buzzard's Bay on Henderer Road where the bridge washed ashore.

On October 29, 1950, water ran through Roseburg's streets after the river flooded. The Creason Hotel had water all through the first floor. Nearly 1,000 people fled their homes as both the South Umpqua River and Deer Creek overflowed their banks. Water was 3 feet deep on Jackson Street, as Deer Creek rose 20 feet in three days. The swinging bridge over the river was destroyed.

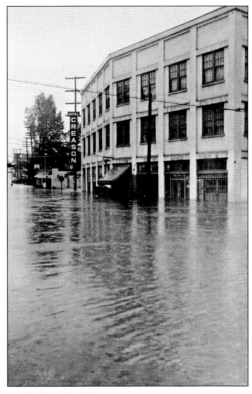

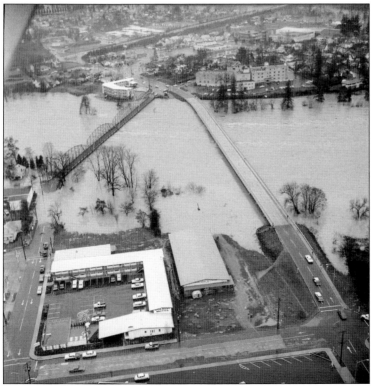

Just before Christmas 1964, Douglas County had the most destructive flood in county history. Bridges and entire houses were swept to the ocean. Those who refused to evacuate were stranded on the roofs of their homes. This view looking west shows the two bridges connecting east and west Roseburg and the original Mercy Hospital in the upper right. Four people died.

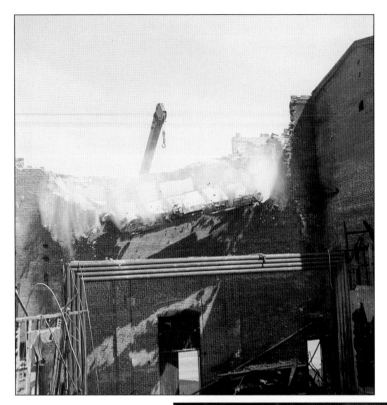

The Indian Theater fire on June 13, 1969, caused an estimated $35,000 in damage to equipment and $50,000 in damage to the building, leaving only two walls intact. The fire started in a popcorn popper, sending fire into an exhaust duct. At the time of the fire, the theater had been entertaining residents for 60 years at 741 SE Jackson Street. Four firemen were injured.

On August 7, 1959, a small fire started around 1:00 a.m. in a trash can outside the Gerretsen Building Supply Company. About 13 minutes later, as it spread, it ignited a 1959 Ford delivery truck loaded with two tons of dynamite and four-and-a-half tons (13,000 pounds) of ammonium nitrate. The Blast leveled eight city blocks, killed 14, and injured 125 people. The mushroom-shaped cloud was seen by an airplane as high as 17,000 feet in the air. Damages were estimated between $10 and $12 million.

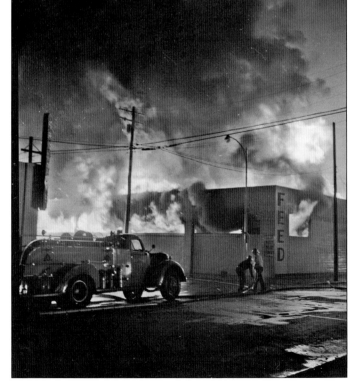

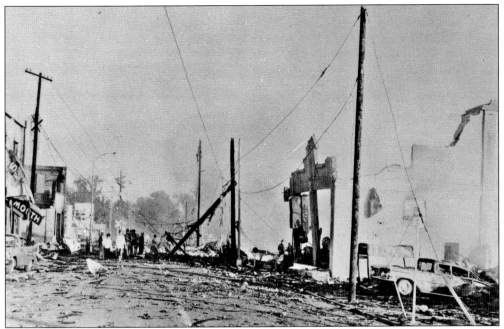

This photograph looks south on Washington Street after the 1959 Blast. Heavy damage was reported for 30 blocks around the explosion's center. Police chief Vernon Murdock said the hardest hit areas included a four-block strip from Douglas to Lane Streets and two blocks from Stephens to Parrott Streets. Every window on Jackson Street was knocked out. Lela Kuykendall died along with her four-year-old daughter Virginia.

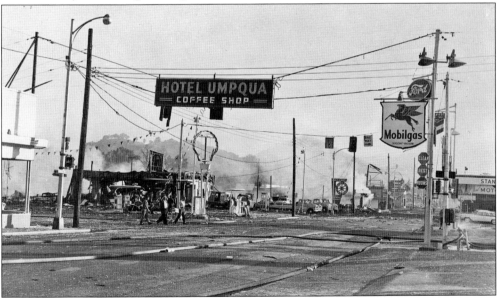

Fires caused by burning debris flashed though the town, starting at least four fires in addition to the major one at the Blast site. Assistant fire chief Roy McFarland and Harry Carmichael were among the first killed. Policeman Donald DeSues was standing next to the truck when it exploded, and he died instantly. Fire departments from as far away as Eugene soon arrived to assist Roseburg. It took four hours to finally control the flames.

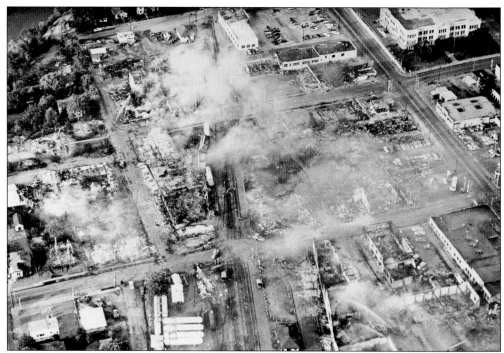

The morning after the Blast, Douglas County sheriff Ira Byrd went up in his airplane to survey the destruction. The fire department was still pumping water on fires, and smoke covered the area. In the top right corner is Central Junior High, which was damaged. In many places only brick walls remained as burned out hulks. The Southern Pacific railroad runs directly through the middle of the photograph.

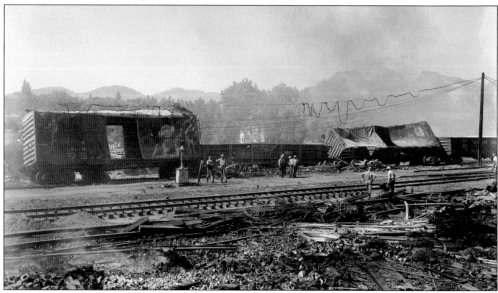

A railroad tank car full of propane was parked near a burning building. Volunteer firemen from Roseburg risked their lives as they struggled to spray enough water on the car to keep it from exploding. The lumber and building supply retail centers in the afflicted area posed extreme danger for anyone fighting the fires. Lyle Westcott, a volunteer fireman, was severely burned.

108

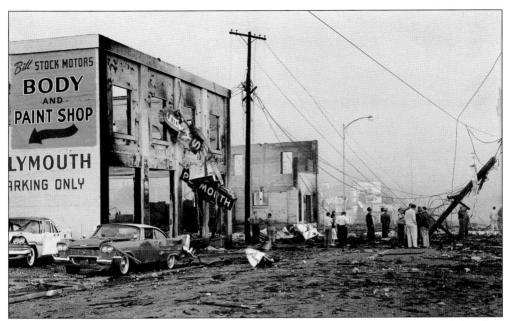

This scene of devastation looks down Oak Street and shows the remains of the Coca-Cola bottling plant on the right, located directly across from the dynamite truck. Next to the corner wall of the plant was the home of William and Eleanor Unrath, owners of the plant. All that was left of their home was the stone fireplace. William died, but Eleanor and their daughter survived. (Courtesy of Summer James.)

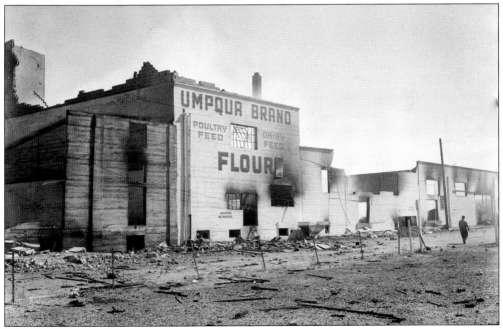

The explosion nearly vaporized the dynamite truck and everything within 100 yards of it. The driver, George Rutherford, had parked and gone into the Umpqua Hotel to get some sleep. The Pacific Powder Company of Washington, the owner of the truck, eventually paid $1,200,000 in civil damages in 1962. They were cleared of criminal charges.

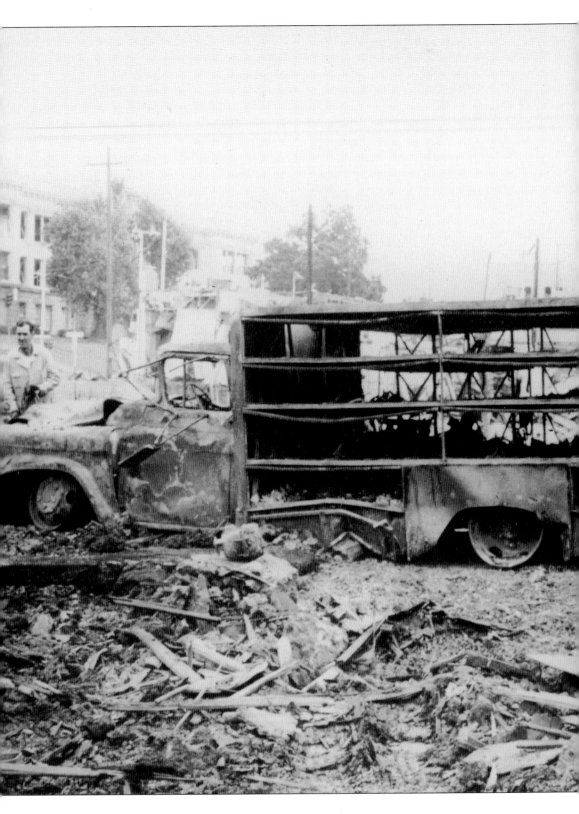

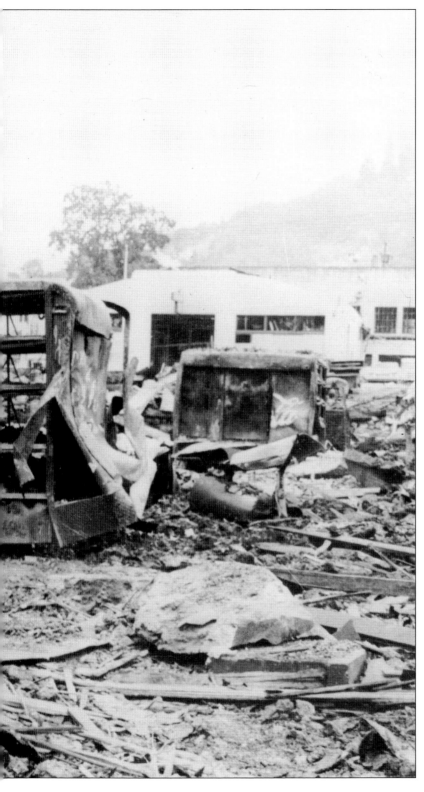

This burned-out Coca-Cola delivery truck conveys the total destruction that followed the Blast. Rubber was burned off the tires and the side panel was bashed in from flying debris. The largest piece recovered from the dynamite truck was a bent steel axle wrapped around a tree five blocks away. The nuts and bolts from the Gerretsen Supply Company instantly became deadly flying projectiles. Some 65 guests from the nearby Umpqua Hotel were evacuated to safety. People living 20 blocks away were knocked out of their chairs. For 8 miles around, people were tossed out of bed. A rooming house one block from the center housed many of the victims. At the time of the Blast, Roseburg had a population of 12,200. (Courtesy of Summer James.)

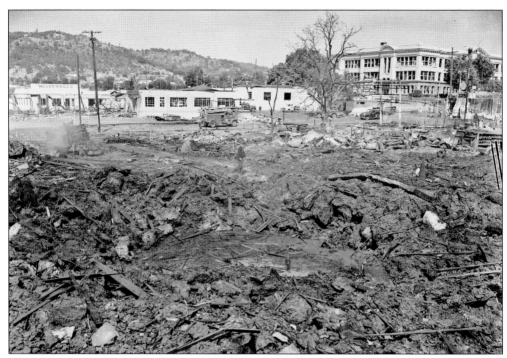

This photograph shows the Blast crater and the irreparably damaged three-story Central Junior High School to the right. The crater created by the truck explosion measured 50 feet across and 20 feet deep. Some 228 buildings were damaged and 72 businesses were totally destroyed. For many weeks it was difficult to buy window glass anywhere in the state as Roseburg residents rushed to repair the damage throughout the city.

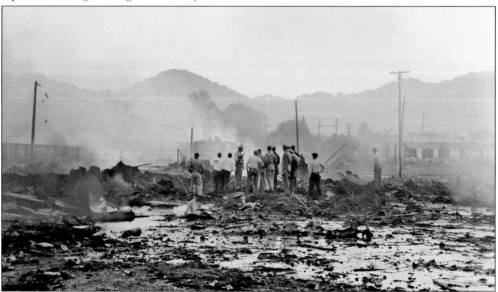

Photographs of the Blast appeared in *Life* magazine and *Reader's Digest*. The images brought close to home the fear of nuclear attack and the dangers of the Cold War to many throughout the nation. Roseburg was able to rebuild based on the fact that 98 percent of the businesses had applicable insurance. No federal government assistance was issued.

Six

FAMOUS FACES
THE NOTORIOUS AND THE ILLUSTRIOUS

Over the years, Roseburg's residents have contributed to many of Oregon's historic firsts. The first female physicians were born here and Oregon's first territorial governor, Gen. Joseph Lane, lived here. Drs. Mary Huntley Sawtelle and Bethenia Owens-Adair challenged the accepted social norms and led the way for all women coming after them. Oregon's first United States district judge, Matthew Deady, owned a donation land claim near town. Hundreds of Chinese workers were shipped into the area in the late 1800s to work in Fendel Sutherlin's mines and on the railroad ,contributing to the area's vitality. Roseburg is the only city in Oregon where two Pulitzer Prize winners spent their childhood—H. L. Davis, writer, won in 1936 and David Kennerly, photographer, won in 1972.

All cities have their share of villains. Samuel G. Brown was the first man in the county sentenced to hang, in 1896, but he escaped. Richard Brumfield was convicted of murder and sentenced to hang in 1922, but he committed suicide. During Prohibition, the saloons and gaming parlors in town were difficult to control. A Main Street bawdy house generated controversy between 1908 and 1915.

Easier to recognize were the builders and the entrepreneurs, the men and women who had the drive and ambition to work hard and succeed. There have been explorers, doctors, lawyers, judges, poets, writers, and politicians raised and educated here. They've gone on to proudly serve their town, their state, and their country. Roseburg has welcomed many famous visitors, and all have received the warm welcome for which Roseburg is famous.

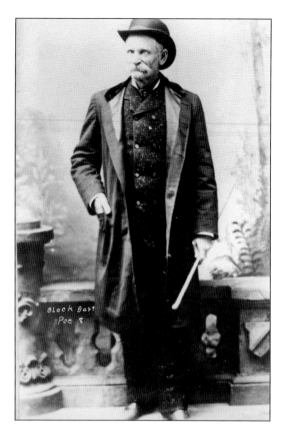

Charles E. Bowles, alias Black Bart, was also known as the Poet (Po-8) Bandit. He regularly robbed the Wells Fargo Company gold shipments carried by stagecoaches between San Francisco and Roseburg. Pursued relentlessly by Wells Fargo detective James B. Hume, Bowles was captured in 1883 and sentenced to San Quentin prison for eight years. A gentleman to the end, he never fired a shot nor robbed a passenger.

DR. R. M. BRUMFIELD

WANTED FOR MURDER!

$2,000 will be paid for the apprehension of the Murderer of W. Dennis Russell.

I hold warrant for the arrest of Dr. R. M. Brumfield, charged with the murder of W. Dennis Russell, near Roseburg, Douglas County, Oregon, on July 13th, 1921.

DESCRIPTION—Dark complexioned; dark hair, wears long pompadour, heavy eyebrows, sharp beady eyes, wears glasses, near sighted when not using glasses; eyes close together and black; age about 38 years; height about 5 feet 11 inches, weight about 180 pounds, walks very erect. Is fluent talker and well educated. Fond of music and fond of cards. Neck rather large. It's quite possible Brumfield may be attired in woman's clothes.

DESCRIPTION OF TEETH—Upper: Left inspid to first molar has a removable bridge, gold saddle and porcelain teeth on this bridge. Two upper centrals well formed and all anterior teeth presented a fine appearance.

Lower: A sanitary bridge extended from lower second brinspid on right to lower second molar. Molar has an inlay attachment.

$1,000 will be paid by Douglas County, and $1,000 recommended by Governor Olcott, to be paid for the apprehension of the murderer. Arrest, hold and wire at once.

S. W. STARMER, Sheriff Douglas Co., Roseburg, Oregon

Richard M. Brumfield, a dentist, murdered Myrtle Creek resident W. Dennis Russell on July 13, 1921. The above wanted poster shows his picture and describes Brumfield. He was arrested in Alberta, Canada on August 12, 1921, and returned to Roseburg for trial. Convicted of first-degree murder and sentenced to hang, he committed suicide in prison on September 12, 1922.

Col. William Thompson became editor of the Democratic newspaper *The Plaindealer* in 1870. In June 1871 he got in a gunfight with the Gale Brothers, editors of a rival newspaper. Thomas and Henry Gale had printed several personally derogatory articles about Thompson. Shortly after the last article Thompson confronted Thomas Gale and expressed his displeasure by spitting in his face and kicking his legs. The next day the brothers (both armed) attacked Thompson on the street. Thompson survived three bullets and Thomas survived a bullet in the chest.

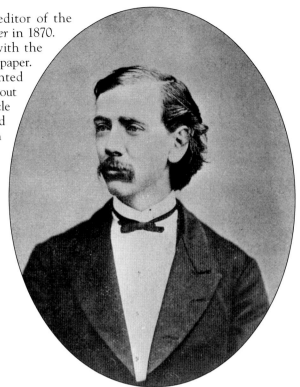

Thomas and Henry Gale were the first editors of the Republican *Roseburg Ensign* and *Umpqua Ensign* in the 1870s. Their rivalry with William Thompson, editor of *The Plaindealer,* escalated into violence on Saturday, June 11, 1871. The Gale brothers attacked Thompson, shooting him in the face, shoulder, and abdomen. Thompson retaliated by injuring both brothers, one of whom died from his injuries a few years later. The brothers were arrested and indicted for assault with a dangerous weapon. They pled guilty, and were fined $100 each.

Mary Huntly, wife of Carsena A. Huntly, was the first white female resident in the Glide area. In 1858, she divorced her husband and went to Salem to attend Willamette University. She was denied a diploma because she was a woman. She graduated from the Women's College of Medicine in New York City in 1872. She and her second husband, C. M. Sawtelle, moved to San Francisco, where they practiced medicine.

In 1871, Bethenia Owens owned a millinery shop and supported Susan B. Anthony during her visit to Roseburg. The night of Anthony's speech, all the saloons in town offered free drinks. On December 20, 1873, Owens left for Philadelphia to become a physician. Dr. Owens-Adair became Oregon's first female physician and the leading proponent of legislation to sterilize the hopelessly insane, criminals, and the feeble-minded.

In 1853, Gen. Joseph Lane built a home near what is now the north end of the Roseburg airport. Lane was Oregon's first territorial governor and lived in Roseburg from 1861 until his death on April 19, 1881. Lane's daughter Emily and her husband, Fred "Creed" Floed, built a home on Douglas Street. General Lane lived with them at the end of his life. The Floed-Lane house is on the National Register of Historic Places and is maintained by the Douglas County Historical Society.

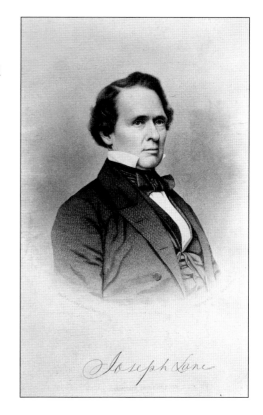

Matthew Deady moved to the Roseburg area in the spring of 1853, and lived there with his family until 1860 on a donation land claim he named "Fair Oaks." Deady was instrumental in establishing court systems in four southern Oregon counties, and twice a year he traveled the 750-mile court circuit. He was appointed United States district judge for the District of Oregon by Pres. James Buchanan and moved to Portland.

Judge James W. and Olive Hamilton built their home in 1895 and raised their four children in it. Hamilton was an Oregon circuit court judge who presided at many of Oregon's earliest criminal court cases. As district attorney, he prosecuted the murderer John Gilman in 1889, and as judge sentenced Claude Branton to hang in 1899, and Elliot Lyons to hang in 1903.

Freeman Brown was the volunteer fire department captain in the late 1800s. He married his wife Alice in 1877. He owned a harness-making shop, served on the city council, participated in several fraternal organizations, and was a major businessman in Roseburg.

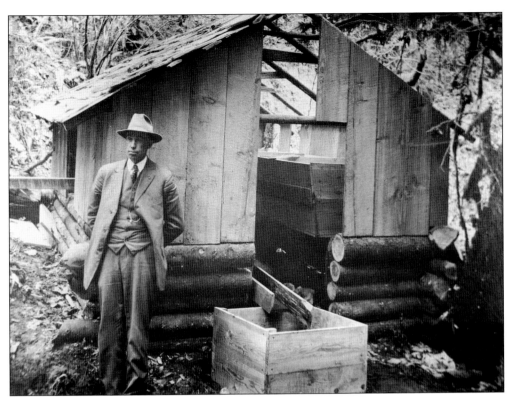

In 1921, Douglas County sheriff Sam W. Starmer investigated and pursued the murderer Brumfield. Starmer was highly respected for his diligence and organization. During Prohibition, he was responsible for reducing the number of bootleggers manufacturing homemade whiskey throughout the county. In the photograph above he is standing in front of an illegal still.

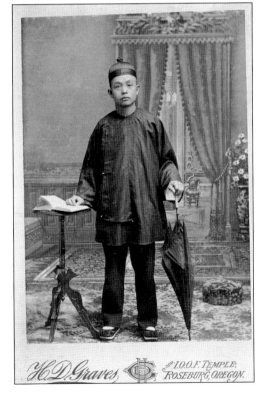

The imported Chinese workers were well accepted in Roseburg. Most came to town to build the railroad and later worked in the southern Oregon mines. A few found other jobs. Lem Queue, pictured at right, worked as a houseboy for Judge J. W. Hamilton in 1890. In 1931, the Umpqua Hotel had a large crew of Chinese men serving in the kitchens and working as staff.

Addison Gibbs, born in 1825, immigrated to Oregon in 1850 and took up a donation land claim. He bought and renovated the old McClallen House Hotel in 1858 and named the addition the American Hotel. In 1860, he was elected governor of Oregon. He died on December 29, 1886, while visiting London, England.

Joseph Micelli was a major contributor to Roseburg's economy and growth. The Micelli family, staunch Catholics, came to Roseburg in 1890 and contributed to many civic endeavors. Joseph was president of the Roseburg First State and Savings Bank (later renamed the Umpqua Savings and Loan Bank). Bricks from his brickyard are still part of many buildings in Roseburg. He was mayor of Roseburg in 1911.

Binger Hermann, born in 1843, started out teaching school in Yoncalla and Canyonville. He moved to Roseburg where he practiced law and served in the Oregon Legislature and the U.S. Land Office, and was a representative to Congress from 1885 to 1897 and from 1903 to 1907. He and his wife, Flora Tibbetts, had seven children, four of whom survived.

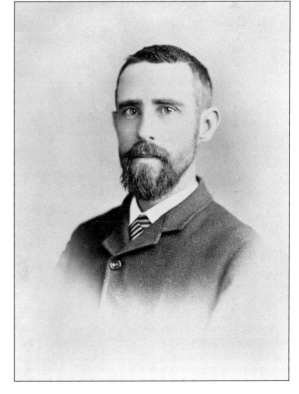

Oscar Fitzland Godfrey was born in Pennsylvania on October 5, 1850. He and his wife Belle moved to town in 1886 and bought a farm near Mount Nebo. When the Douglas County Bank was organized in 1883, he purchased shares and was elected president of the bank in 1891. On October 31, 1901, he sold his shares in the bank to Robert A. and James H. Booth.

Eva and Evea Applegate were born in 1881 to George "Buck" and Flora Applegate. Their father carved two elaborately decorated violins for his twin daughters. George was the son of Charles Applegate, one of the three famous Applegate brothers who immigrated to Oregon in 1843. Jesse and Lindsay Applegate along with Captain Levi Scott opened the Scott-Applegate Trail in 1846.

Lee C. Rodenberger was the first elected police marshal in 1872 and was paid $75 a month for his services. Duel Jarvis, pictured here, was the first marshal appointed by the mayor and served between 1902 and 1906. He also owned a clothing store on Sheridan Street. The city paid for his badge, but Jarvis provided his own uniform. It wasn't until 1922, when the first car was purchased for police use, that the city started to provide uniforms.

On September 29, 1880, Pres. Rutherford B. Hayes spent the night with the family of Judge William R. Willis. He and his party were traveling north by stage from Redding, California, and boarded the railroad in Roseburg. His wife Lucy Webb Hayes, a staunch temperance proponent; Gen. W. T. Sherman; and others accompanied him. The extravagantly decorated town hosted a grand celebration at the Metropolitan Hotel.

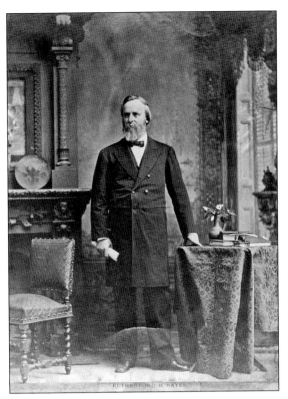

Pres. Theodore Roosevelt arrived on May 21, 1903. After changing engines, which required only a few minutes, the train was on its way again heading north to Portland. Engineer Richard Morris was working the throttle. Roosevelt was president from 1901 to 1909. Sen. Binger Hermann is pictured to his right as Roosevelt appeared briefly to the waiting crowd.

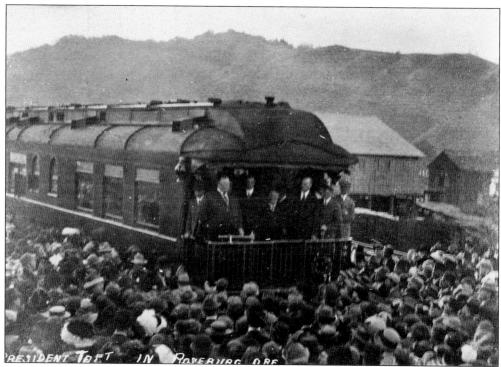

William H. Taft was the 27th president of the United States, from 1909 to 1913. On August 23, 1915, Taft was traveling from Portland to San Francisco by train and stopped in Roseburg. It was late at night, so the former president only spoke for 10 minutes from the back of the train before saying good night to about 100 supporters.

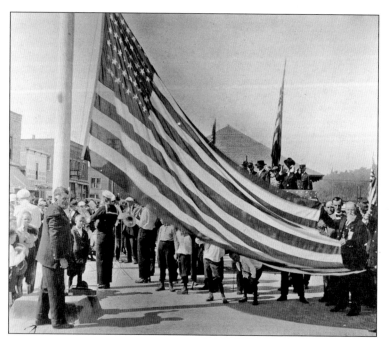

During World War I, Capt. Edward Daniel Hagen (standing to the left in front of the flagpole) raised the U.S. flag at the Southern Pacific depot each morning and lowered it each evening. It was Roseburg's way of showing support for the soldiers passing through on troop trains. This photograph was taken in 1916, on the day the flag was dedicated and raised for the first time.

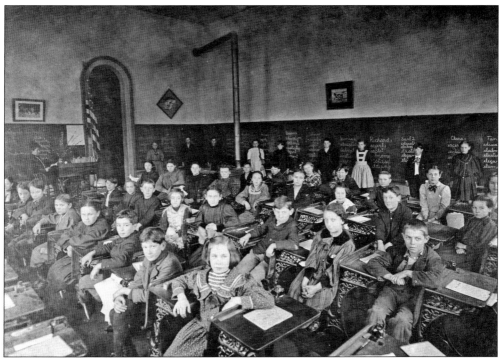

This photograph shows a fourth or fifth grade classroom at Lane School in 1909. That year Effie Willis was the fourth grade teacher and Lena Callison was the fifth grade teacher. Only unmarried women could be teachers at that time. The school had 12 classrooms and two recitation rooms. In 1900 it had an enrollment of 688 students. This building was the first and only school in Roseburg until 1904, when the Roseburg High School was built. At that time the name was changed from Roseburg Academy to Lane School, honoring Gen. Joseph Lane. It burned on February 3, 1916.

There were 18 students in the 1908 Roseburg High School graduating class. From left to right, they were: (first row) Will Thornton, Archie Jackson, Everett Harpham, and Ross Goodman; (second row) Paula Campbell, Walter Fisher, Reah Cook, Lucy Bridges, Francis Risely, and Ruby Burrow; (third row) Myrtle Devore, George Wharton, Fay Kitchin, Vivian French, Carlton Spencer, Ruth Gibson, Ross Townsend, and Muriel (Merle) Williams.

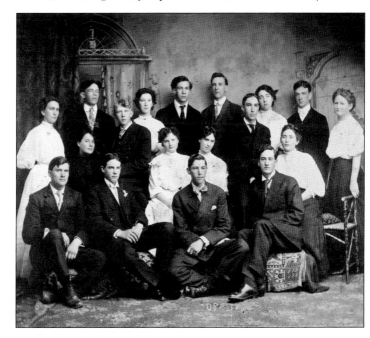

Kenneth Ford was born on August 4, 1908 in Asotin, Washington, and died February 8, 1997. He bought his first sawmill in 1936, starting the empire of Roseburg Lumber Company, which lasted beyond his lifetime and created jobs for thousands of people. He founded Roseburg Forest Products in March 1985, creating one of the largest family-owned companies in the United States. The Ford Family Foundation has contributed millions of dollars to projects all over Oregon, including $500,000 toward Roseburg's new county library.

Richard Nixon came to Roseburg on September 20, 1952, to campaign for the vice presidency of the United States with Gen. Dwight D. Eisenhower, who was running for president. Nixon served as vice president from 1953 to 1961. He and his wife Pat also visited during his campaign for the United States presidency in 1968. He gave his speech from the train's rear platform.

In 1964, Nelson Rockefeller made his second attempt at the United States presidency. Republicans throughout Oregon considered him to be a front-runner against Barry Goldwater of Arizona. He won Oregon's primary, but dropped out of the presidential race after losing the California primary. Rockefeller served as vice president after Gerald Ford became president. He is shown here with Thomas Garrison, a prominent banker, lawyer, and past Roseburg mayor.

Robert Kennedy visited Roseburg in the spring of 1968 as he campaigned in the United States presidential election. He is shown here speaking from the Douglas County Courthouse steps. He defeated Eugene McCarthy in the California presidential primary, but was shot June 5, 1968, and died the next day. Kennedy was a United States senator from New York from 1965 until 1968, before running for president.

Discover Thousands of Local History Books
Featuring Millions of Vintage Images

Arcadia Publishing, the leading local history publisher in the United States, is committed to making history accessible and meaningful through publishing books that celebrate and preserve the heritage of America's people and places.

Find more books like this at
www.arcadiapublishing.com

Search for your hometown history, your old stomping grounds, and even your favorite sports team.

Consistent with our mission to preserve history on a local level, this book was printed in South Carolina on American-made paper and manufactured entirely in the United States. Products carrying the accredited Forest Stewardship Council (FSC) label are printed on 100 percent FSC-certified paper.

MADE IN THE USA